Magnolia

A BRIEF HISTORY

Lisa Peek Ramos

Charleston London

THE
History
PRESS

Published by The History Press
Charleston, SC 29403
www.historypress.net

Cover design by Marshall Hudson.
All images are courtesy of the author unless otherwise noted.

First published 2008

Manufactured in the United Kingdom

ISBN 978.1.59629.453.0

Library of Congress Cataloging-in-Publication Data

Ramos, Lisa Peek.
Magnolia : a brief history / Lisa Peek Ramos.
p. cm.
Includes bibliographical references.
ISBN 978-1-59629-453-0
1. Magnolia (Gloucester, Mass.)--History. 2. Gloucester (Mass.)--History. 3. Magnolia (Gloucester, Mass.)--Biography. 4. Gloucester (Mass.)--Biography. 5. Magnolia (Gloucester, Mass.)--Buildings, structures, etc. 6. Gloucester (Mass.)--Buildings, structures, etc. 7. Historic buildings--Massachusetts--Gloucester. 8. Natural history--Massachusetts--Gloucester. I. Title.
F74.G5R36 2008
974.4'5--dc22

2008005096

Notice: The information in this book is true and complete to the best of our knowledge. It is offered without guarantee on the part of the author or The History Press. The author and The History Press disclaim all liability in connection with the use of this book.

Magnolia, Mass. (1932)

I've traveled North, South, East and West.
I've roamed the whole world o'er.
The place however I love the best
is on New England's shore.

Magnolia is the name it bears,
its charms enchant, entice.
The answer to a Pilgrim's prayers,
a part of paradise.

The sky is brilliant, sapphire blue,
the ocean broad and free.
And rugged rocks of somber hue
divide the land and sea.

The air is sparkling, cool and clear,
the foliage bright and green.
Each gift of God is gathered here,
in harmony serene.

The breakers boom, and swirl and sweep,
through chasms in the rocks.
And over all the mighty deep,
the seagulls whirl in flocks.

The woods are shady, dense and strewn
with boulders, ghost-like gray.
Sea breezes in the tree tops croon,
a lullaby all day.

Along the beach of Kettle Cove,
the waves recede and break,
while bathers in a countless drove,
their daily sunbaths take.

The fish hawks, in their search for food,
alight, and preen, and flap
upon the bobbing blocks of wood
that mark each lobster trap.

The harbor into Gloucester town,
is specked with flashing sails.
Here ships that on the sea go down,
ride safe from lashing gales.

The mournful cries of birds are heard,
on wave-worn Norman's Woe,
where once a famous wreck occurred,
amidst the ice and snow.

The bell buoys toll, in solemn tone,
each time the waves dash high.
A lighthouse on its rock-bound throne,
guards all with watchful eye.

Though I have traveled far and near,
From Maine to Singapore,
You're sure to find me every year,
upon Magnolia's shore.

Where the days are bright and sunny,
the nights starlit and calm,
where the air is sweet as honey,
the breeze a soothing balm.

—*Krewson*

Contents

Dedication

This book started as a composition that was required to obtain my bachelor's degree. The information I learned sparked my interest in the history of Magnolia. At age thirty-four, and still in college, I got pregnant with my first son. It was then that I felt it was my mission to extract from my grandmother, a Magnolia native and founder of the Magnolia Historical Society, all of the information she knew about Magnolia history in order to hand it down generationally. The birth of my second son, two weeks after college graduation, heightened my enthusiasm for knowledge and motivated me to write this book. Still, I have learned more from motherhood than I ever did in college.

This book is dedicated to my grandmother, Frances C. Hines, who has devoted her life and love to the people of Magnolia and to preserving the history of this village. I cherish the time I have been able to spend with her, and hope this book will further her purpose and continue to keep the interest in Magnolia history thriving.

I dedicate the time and effort I have put into this book to my sons. My hope is that all generations will learn from this book, not only the history of hometown and family, but also that hard work and perseverance always pay off.

Everything happens for a reason. Pass it on.

Special Thanks

Frances Hines, for being such a wonderful grandmother, for preserving the history of Magnolia and for sparking and encouraging my interest in it.

Mike Ramos, my husband, for always encouraging me to continue working on this book and supporting my efforts, and for making our family the most precious gift in life.

Sally and Sandy Peek, my parents, for always inspiring me to do the best that I could, for cheering me on when things went well and for being there when I needed help, no matter what.

James Cook, for taking the time and effort not to just tell me but to teach me the history.

Linda Bouchard, of Snow Harbor Graphics, a big thank-you from "Miss Magnolia."

My family and friends, no matter where you are, for believing in me always.

And to all of you, who filled out my original questionnaires for my college thesis, who took the time to tell me about your own histories and who waited the many years it has taken me to complete this book.

I thank you!

Letter from the President

First, I would like to thank Lisa for the hard work she put into producing this book. For quite a few years now, those of us who are interested in the history of Magnolia have talked about producing an updated history of our little village. No one else ever seemed to be able to find the time to do it. Even though she is a working mother of two young boys, Lisa somehow managed to make the time. In the modern world, that is not an easy thing to do.

Lisa grew up in Magnolia, and is descended through her mother (Sally Peek) and grandmother (Fran Hines) from Henry West, who came to Magnolia to work in the ice business in the late 1800s. She was raised here, was married in Saint Joseph's Chapel to Michael Ramos and lives near Ravenswood Park. For generations, her family has been known for its interest in and commitment to the community here. It seems Lisa caught the history bug from her Grandmother Fran, who is considered to be the driving force in the founding of the Magnolia Historical Society.

This book is not meant to be any sort of extensive or complete history of Magnolia, but instead an addition to the two books produced earlier: *The Story of Kettle Cove*, by Alice Foster in 1899, and *Magnolia on Kettle Cove*, by Hildegard Hart in 1962. It has been forty-five years since anything has been published about Magnolia. This book recounts some of the stories told in the previous books and adds more information that covers the period since 1962. There is still so much more that can be written, but that is left to be done some time in the future. I urge anyone who is interested in the history of Magnolia to read all three books and visit the Magnolia Historical Society in the Fran Hines Historical Room, located in the Magnolia Library Center at 2 Lexington Avenue.

James A. Cook
President
Magnolia Historical Society

Magnolia History

Some persons say, in Monterrey, the moonlight is divine.
Yet, others swear, it can't compare, to that in Caroline.
And then again, some say in Spain or Venice it is best,
while many more will argue for the Tropics or the West.
But ev'ry night the moon shines bright, I always yearn to be
in just one spot, one peaceful plot, Magnolia by the sea.
—from "Moonlight in Magnolia"

The first trip to Cape Ann was made by Chevalier Champlain in July 1605. He sailed with a small assemblage to discover what we now know as Cape Ann. He was confronted by Native Americans and promptly sailed around Eastern Point. He landed his boat in the harbor, which he named *Le Beauport,* "beautiful harbor." Again he was greeted by Native Americans, who had decided to ambush and kill the white-faced trespassers. Champlain became aware of the plot for a surprise attack and again retreated, this time returning home.

In 1621, Captain John Mason received a grant for "all the land from the river Naumkeag around Cape Ann to the river Merrimack." This was, in fact, the first land grant for Cape Ann, although it never came to fruition.

In the year 1623, King James of England chartered an expedition of men to seek favorable fishing grounds. Later that same year, numerous men landed in Gloucester Harbor at Half Moon Beach. Although they had no land granted to them, the colony "squatted" and fished here. Before the boat left to market the "good catch," it was decided that some of the "spare men" would stay to continue the settlement.

The "good catch" still was not enough to financially support a return to the Cape Ann area. Subsequently, the king granted a charter to other nobles in his name. Apparently this same scenario occurred numerous times. Men from England would raise capital to enter the fishing business at Cape Ann, and soon would fail. The soil in this area was simply not adequate to support farmland and so the men had to return to England to sell their catch, raise more capital to return and so on. The men who were left behind would find little pockets of flatland to cultivate and bear through the winters. This cycle of voyages and failures continued until 1625, when Roger Conant was chosen as governor of the Massachusetts Bay Colony, an expedition sent in the

name of King James under the direction of Reverend John White to, yet again, try the fishing business.

The Plymouth Colony Pilgrims also decided to test the waters at Cape Ann in 1626. In order to gain control, they sent Edward Winslow to England to raise capital and acquire a legal claim to the area. Upon his return, the Pilgrims were armed with all they needed to enter the fishing business competition. Serious about their endeavor, they sent their "salt man" up from the south shore to assist in the operations.

Many of the businessmen in England, as well as the Massachusetts Bay Colony crew, were opposed to the Pilgrims' fishing venture and decided to send a squad to "seize all the provisions and the stages" of the opposing colony. The captain of the "semi-piratical" ship was named Hewes. He demanded that Plymouth Colony surrender, and with that he prepared for a siege.

Captain Miles Standish, a Pilgrim troublemaker, soon arrived and refused to admit defeat. The two leaders commenced a battle of heated words that may well have lead to bloodshed at Stage Fort (named for the "stages" used to prepare the fish) if the levelheaded Roger Conant had not suggested a compromise in which each group maintained separate fishing stages. This proposal was accepted by both parties and the predicament was resolved.

In 1626, Roger Conant headed, with his own group, toward Salem in search of more favorable soil. The colony migrated down an old Native American trail along the future Hesperus Avenue, across the beaches in Magnolia, Manchester and Beverly and on to Salem. Oral history suggests that some of the not-so-noble members of the colony remained in this granite-filled area to persevere with the settlement. It is not difficult to conclude that the most favorable soil must have been on Magnolia Avenue, as this is where the majority of the first homes and farms were built.

Remaining under the governorship of Roger Conant, the affiliate members of the Massachusetts Bay Colony in this area were: William Jefferies, Edward Norman and his son John, William Allen and John Black.

The years 1622 to 1690 have been identified as the time of "great migration." In the 1630s, "under the leadership of the son of Rev. John Robinson," there was an influx of people associated with the Pilgrims who settled in the Annisquam area. By 1642, there were enough people in Kettle Cove to build a town. It was in that same year that Richard Blynman, John Knowlton and Thomas Millett arrived in the area to take up residence. It was also in the same year when Gloucester was officially incorporated as a town. Although John Smith yearned for the name *Tragabigzanda*, "the town took its name from the great Cathedral City in South-West England, where it is assumed many of its occupants originated."

On August 15, 1907, a bronze plaque was erected at Stage Fort Park on Tablet Rock. The plaque states:

> *On this site in 1623 a company of fishermen and farmers from Dorchester Eng. Under the direction of Rev. John White founded The Massachusetts Bay Colony from that time the fisheries the oldest industry in the commonwealth have been uninterruptedly pursued*

from this port. Here in 1625 Gov. Roger Conant by wise diplomacy averted bloodshed between contending factions one led by Miles Standish of Plymouth the other by Capt. Hewes a notable exemplification of arbitration in the beginnings of New England. Placed by the citizens of Gloucester 1907.

I hope that you, too, now understand what the plaque actually stands for. I invite you to visit Tablet Rock at Stage Fort, close your eyes for a moment and envision what it must have been like to be one of the few men here in the 1600s.

Kettle Cove

Legends

It wasn't until 1679 that land at Kettle Cove was granted to the settlers in the name of the queen for "service in the Indian war."

It is still unknown how exactly Kettle Cove got its name. Exploration of the history of this village shows that Magnolia was once called Kettle Cove in the seventeenth century. There appear to be many theories as to why it was given that name. Unfortunately, all documents that may contain the "true" information have not been uncovered at the time of this writing. However, there are many legends. Some claim that Kettle Island was at one time joined to the mainland by a bar of sand and rocks, thus giving the coastline the shape of a kettle. Others say the first settlers, who were given fishing rights by the king of England, were named Kettle and therefore called the area after themselves. (Young John Kettle was also granted land in "Macrel Cove," but nobody knows where it is.) Yet another myth states that at that time, stationary fishing nets were called *kettl'*, and the name may have been derived from this term. Still more believe the land was purchased from the Native Americans for a copper kettle.

Another parable of Kettle Island has been handed down for generations. According to the legend, Kettle Island was once a peninsula that reached out to Shore Road. A witch called "Old Granny" and a lovely maiden named Elsie resided on Shore Road at the foot of the peninsula. An elderly farmer, who owned the property of Kettle Island, allowed Old Granny and Elsie to pasture their sheep there. Meanwhile, the farmer's son fell desperately in love with Elsie and sought her hand in marriage.

One day, while Elsie was sitting on the rocks, a dark stranger disembarked from a majestic ship. He told Elsie of foreign shores and "princely places, with courtiers and ladies fair, but none as fair as she." They met on several occasions, and with each visit, their hearts awakened with love and enlightenment.

Meanwhile, as Old Granny's sheep were pasturing on the farmer's land, the farmer decided he must either be paid for the lease of the land or Elsie must marry his son. The former was impossible, so the wedding day was fixed. Old Granny threatened to throw Elsie from the rocky cliffs if she did not comply with the marital demands. Old Granny kept Elsie under lock and key until the day arrived.

When the day did finally arrive, there was a terrible storm. Elsie's heart sank as the hours passed and the ordeal drew closer. She felt no hope of being rescued by her dark-haired love, because no ship could bear the rough waters. At sunset, Elsie stood at the edge of the rocky cliffs, awaiting her death. Old Granny pushed her over the cliffs and she fell down the rocks and into the turbulent water. Just then, a strong arm seized her and drew her into a boat. It was, in fact, her dark-haired sweetheart.

In the gray of the next morning, Old Granny's body was washed ashore along with the sheep, all of which had drowned as they tried to cross the neck of the peninsula during the great storm. From that day on, the land gradually washed away until there was nothing left but a sunken reef connecting Kettle Island to Magnolia Point. A curse was said to have been put on the point—no cow, horse or sheep could survive on Magnolia Point for more than six months.

Becoming Magnolia

In the year 1876, the name Kettle Cove was changed to Magnolia in recognition of the wildflower *Magnolia glauca* that was discovered in 1809. *Magnolia glauca* is unlike the hybrid Magnolia trees many residents have planted in their yards today. In fact, the flower is a butter-yellow color and blooms in early July. The wild Magnolia still grows in this area. It can be found mainly in what are now Ravenswood Park and Magnolia Woods. There are also species inland, behind the old bookstore on Western Avenue, at a private home in East Gloucester Square and at the first house after the stoplights on Eastern Avenue in Gloucester. This is the northernmost region the flower is located.

The first place to use the name Magnolia was the Stagecoach Inn, back in the 1870s.

Early Landowners and Settlers

Richard Blynman

Richard Blynman, a religiously devoted and educated man, arrived in Plymouth Colony in 1640. A native of Great Britain, he came to New England with several Welsh gentlemen by invitation of Edward Winslow of Plymouth. He originally settled in Green's Harbor, which is now Marshfield, Massachusetts. He was then asked by commissioners to come to the Cape Ann area as a member of the church. It is believed that Blynman's dwelling was near the "meetinghouse" on what we now know as Centennial Avenue, near George's Coffee Shop. Although he lived in Gloucester, he received a grant of eighty acres of land in Kettle Cove as payment for minister services. This land, known as Blynman Farm, stretched from what is now Raymond Street in Manchester-by-the-Sea, over the hill past the former Oakwood Retirement Home, onward to what is now Route 127, across the duck pond and into the great beyond.

At the time, all of Blynman's bequeathed land was said to be within the boundaries of Gloucester. Manchester had "lost" its records of city lines. This created controversy between Gloucester and Manchester.

Magnolia, being part of Gloucester, held town meetings at the green in Gloucester. The green was located at what is now Grant Circle. (Remember, back then one didn't get into an SUV and drive ten minutes to Gloucester. By horse and wagon, or by foot, going to the town meeting was an all-day affair.) Also, in the seventeenth century, there was no separation of church and state. It was mandatory to belong to the church, pay taxes to it and to attend the town meetings. In order to own land, one had to be a member of the church. Manchester's meeting green was much closer to Blynman; therefore, he declared himself a resident of Manchester and with him went his land. It is still undetermined whether the cemetery off Magnolia Avenue in Manchester was part of Blynman's land. It is believed that John Kettle and many other early settlers of questionable character are buried there.

An agreement was made to settle the boundary for Manchester to include Blynman's land. The boundaries of Gloucester became located four miles, as the crow flies, from the center of Governor's Hill. This has been a sore spot between Gloucester and Manchester for quite a long time.

Regardless of the boundary dispute, Blynman did become an asset to Gloucester. In 1643, he was given permission to dig a ditch between the Annisquam River and

Gloucester Harbor. This enabled easier travel by boat to the harbor. He also provided residents with the Blynman Bridge. It was one of the first "cut" bridges that opened and closed to allow boats to enter and exit waterways. Upon completion, it was declared a toll bridge. This enabled Blynman to build his fortune by collecting a toll to cross under and over his bridge. Tolls were paid in cash and chickens. As the bridge was operated manually at the time, fines were imposed if one "left the bridge open."

Today, "the cut" is thankfully not a toll bridge. It is, however, the busiest drawbridge in the United States and has been since 1956. Gloucester and Magnolia residents will attest to that fact.

Blynman School

Blynman School was first established in 1850. Its first location was on the cemetery side of Magnolia Avenue at number 77, where Long Hill Road is now. The building was then moved to Shore Road in 1872, where it was used by the McQuarry family as an establishment for shoeing horses. The location of the relocated building was at the site of the cement, two-car garage diagonally across from the pier.

The new "Little Red Schoolhouse" was built in 1895 at 48 Magnolia Avenue, where it stands today. In its early stages, the school encompassed grades one through nine and had very few pupils. For example, in the 1920s, first grade consisted of only Margaret Heisey. Back then, the Little Red Schoolhouse was the extent of local children's

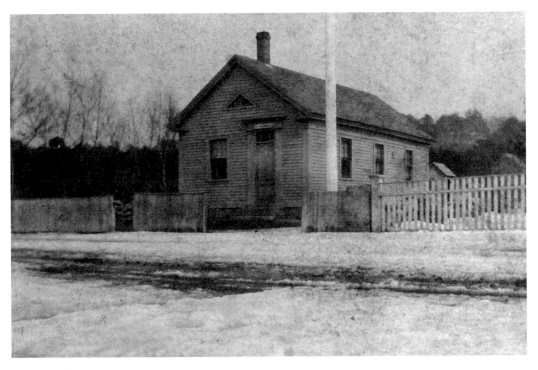

The first Blynman School, established in 1850, was located on the cemetery side of Magnolia Avenue in the grassy area near Long Hill Road. *Magnolia Historical Society.*

education, because either their families could not afford to send them to Gloucester Central Grammar High School, or they had to work for the family business. Keep in mind, there were no school buses at that time.

Many Magnolia families have generations of members who attended Blynman School. For example, within my own family, my great-grandfather Albert Leonard West attended Blynman in 1892, when it consisted of nine grades. (His teacher, Martha Burke, began a fifty-year teaching career at Blynman that same year.) His daughter, my grandmother, Frances Caroline (West) Hines attended Blynman in 1934, when it encompassed only four grades. In the 1950s, when my Aunt Carol (Hines) attended, there were only two grades. Soon after that, the Blynman School was closed and used as a community center.

It was again opened as a school in 1964. I attended Blynman School in 1974, for first and second grades. (Thank you to Mrs. Connie Hines for always holding one end of the jump rope!)

The Blynman School closed again in 1978 and became a school for "problem" children. It has since changed hands numerous times and was most recently used as a day care center, operated by Magnolia native Sharon Lowe. In September 2007, the "Little Red Schoolhouse" was forced to terminate the lease, as the city had increased the rent to an amount that was not feasible under the center's budget. At this time, the building has been termed a "surplus property to deal with."

In 1649, Reverend Blynman left the area and moved to Connecticut. His reasoning for the move was because of "unhappy dissensions" that drove him from his ministry. History reveals that Blynman was "not a man of understanding character." He stated

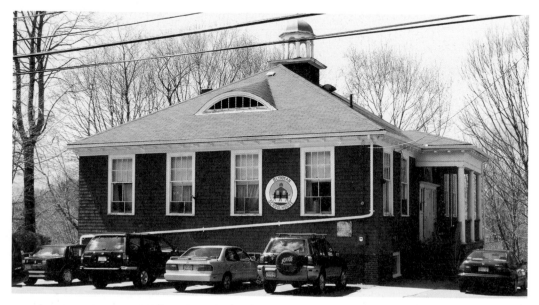

The "new" Blynman Schoolhouse at 48 Magnolia Avenue, 2007.

that he had received "ill treatment" from the people here. Blynman was not only a reverend, but also a clerk. When he left the area, he took with him all of the records from 1642 to 1649, including birth, death and marriage certificates. The records have never been recovered.

Knowlton Family Knowledge

Several acres of land that were originally part of the Blynman grant were sold to Thomas Millett and later to the Goldsmith family. In 1821, a gentleman by the name of James Knowlton purchased seventeen acres of land on Magnolia Point from the Goldsmith family. For close to fifty years, the large Knowlton family, many of whom are now buried in the Magnolia Cemetery, had a great farm on the land. In 1867, they sold most of the land to Daniel Fuller.

The remaining land owned by James and Nancy Knowlton was divided amongst their children upon their deaths. Their son Allen was given the land on the west side of Magnolia Avenue; James was given the area to the east; and their daughter, who was married to Bernard Stanwood, inherited the Norman Avenue section.

Allen Knowlton used his land to establish the small Crescent Beach Hotel in 1872. Over the next few years he enlarged it and soon could accommodate 150 guests. He then renamed his large hotel the Blynman Hotel. After running the hotel for twenty years,

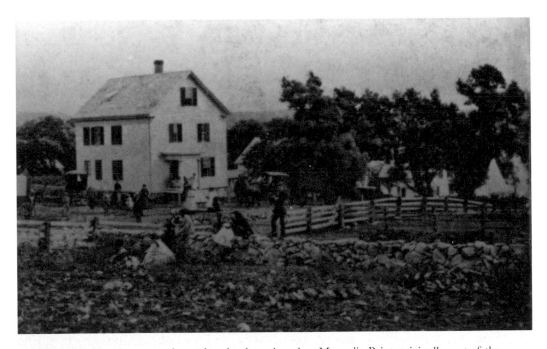

The Knowlton Farmhouse was located on land purchased on Magnolia Point, originally part of the Blynman grant. Of the fourteen original homes built in Magnolia, this is the only one that is no longer standing. *Magnolia Historical Society.*

the eighty-acre estate was purchased by William Henry Coolidge, who, in 1917, built the structure Oakwood as a forty-room, seventeen-bath private home. Coolidge, his wife May and their four children lived in the house until 1944. The estate was then sold to Mrs. Levie. The land was divided, and the area including the duck pond was sold as a private residence. The current owners of the duck pond side continue to display the name Blynman Farm on their barn. Mrs. Levie sold the establishment to Beverly Enterprises and it was converted into Oakwood Retirement Home (601 Summer Street, Manchester). It remained elderly housing until 2003, when it was purchased by Leslie Lynch, of Merrill-Lynch, who was in the process of renovating it into a private home and horse stables at the time of this writing. Rumor has it that the neighbors are not pleased with the addition of the horse arena and they have tried to legally oppose it. Ms. Lynch has filed papers to demolish the structure and build housing on the lot.

The Knowlton's homestead was originally built by a freedman named Scipio Dalton on the upper section of Magnolia Avenue. The house itself was purchased by James and Nancy Knowlton and was then moved to a location between what are now numbers 3 and 5 Magnolia Avenue. The home was later inherited by their daughter and her husband, Bernard Stanwood, and converted into the Willow Cottage in 1876. The Willow Cottage served as a bed-and-breakfast for many artists of significance. It was in an inspiring location on the top of a rolling meadow that had views straight to the ocean. (See more in the section on Willow Cottage in Homes, Hotels and Other Buildings.)

A small area now known as Knowlton Park, named for the Knowlton family, is located between Shore Road and Fuller Street, adjacent to the Magnolia Fire Station. The park was purchased by C.B. Mitchell, husband to one of the Knowlton girls, and donated to the city. Out of respect, the city inscribed the name "Knowlton Park" into a rock within the park. Cathie Hull and I placed a stone bench in the park in 1999 as a memorial to "Best Friends."

Today, Knowlton Park prevails as a serene place to view the magnificent harbor.

Millett Family Memoirs

Born in 1605, Mr. Thomas Millett came from England on the ship *Elizabeth of London* at the age of thirty. He brought with him his wife Mary and their two-year-old son Thomas. The family first settled in Dorchester, Massachusetts, where they had five more children: John (1635), Jonathan (1638), Mary (1639), Mehetabel (1641) and Nathanial (1647).

Mr. Millett succeeded Richard Blynman as the "educated man" in the village. He was also the first to purchase some of the land originally granted to Blynman. With that, Millett moved his family of eight to Magnolia. Thomas Millett died in 1676.

In 1655, as the eldest of six children, Lieutenant Thomas Millett inherited from his father land thirty acres from the head of Little River to Kettle Cove. The land was spread between the boundaries of Gloucester and Manchester, and for reasons much like Blynman's, the Millett family became residents of Manchester.

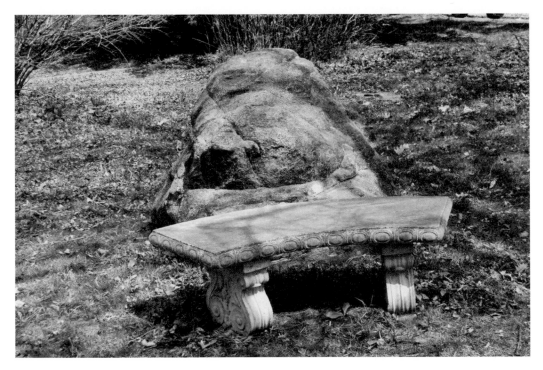

A rock and bench located in Knowlton Park, 2005. The rock is inscribed "Knowlton Park." The bench is a dedication to "best friends" and was placed in the park by Lisa Ramos and Cathie Hull in 1999.

In 1688, Lieutenant Thomas Millett "was one of many who refused to pay the odious tax imposed by the governor Sir Edward Andros." Millett was arraigned and fined forty shillings in Salem.

Sadly, Lieutenant Thomas Millett was later killed by Native Americans in Brookfield, Massachusetts. His land was passed to his family, who eventually sold all of it to John Gilbert.

Nathaniel Millett (1647–1719) received grants of land on the Annisquam River, but settled in Kettle Cove about 1700. Nathaniel and his wife Ann Lister had eleven children, most of whom settled in Kettle Cove. One son, Nathaniel, was drowned in Manchester at the duck pond on Summer Street in 1724 at the age of forty. Another son, Thomas, was drowned at Casco Bay in 1722 "by a land flood overflowing ye cottage and carrying of it away." Both father and sons are buried in Magnolia Cemetery.

At this time, there are no known Milletts left in this area, but the Millett family records can be found at the Magnolia Historical Society.

Gilbert History

In 1704, John Gilbert, great-grandfather to Addison Gilbert, arrived from Wenham, Massachusetts. Mr. Gilbert purchased twenty acres of land extending from Gloucester

to Manchester from the Millett family. In 1745, he sold the house and land to his son Jonathan. Jonathan had a son Samuel, who in turn had a son Addison.

Addison Gilbert was born in the house at the corner of Magnolia Avenue and Western Avenue in 1808. In his adulthood, he became a merchant and banker. He was the incorporator and first president of the City National Bank, established in 1876. His business habits were steadfast and full of integrity. He had a great interest in public affairs and served as a selectman on the legislature, on the school committee and as auditor of town meetings. Addison Gilbert never married. He resided with his sister in a house near the harbor.

Upon his death, his will was read on February 13, 1888. Addison had made specific bequests totaling $234,700. He left $31,000 to friends and family. His portrait, "painted in oil," went to Gloucester National Bank; the large portrait "in crayon" was given to Cape Ann Savings Bank and another oil painting of himself was given to the Sawyer Library. Money was also given to organizations including the Female Charitable Association of Gloucester, the Massachusetts Society for Prevention of Cruelty to Animals, the Fireman's Relief Association, Cape Ann Historical Society and Oak Grove Cemetery. His residence and $75,000 in trust were designated "to found and establish in the City of Gloucester a home for the Aged and Indigent Persons, not under 60 years of age." This became the Gilbert Home for the elderly until 1982, when it was sold and the trust was dissolved.

His largest bequest was for $100,000, "to found and establish…a free hospital." The building, he stated, should be brick with the name "The Gilbert Hospital" presented in marble above the front door.

As Joseph Garland notes in his book *The North Shore*, "Addison Gilbert Hospital was scheduled to open in July 1897, but before it was officially opened, Dennis McNeary was brought in with fractures of the arm and pelvis, severe facial lacerations and heavy bruises." Dennis was walking down the railroad track and was struck by the train. He was treated by Doctor J.E. Garland. After five weeks of treatment, Dennis discharged himself from the hospital, as he did not want to go to the poorhouse.

Today, the Addison Gilbert Hospital remains the only hospital in Gloucester.

Daniel Fuller

Daniel Fuller was born in Swampscott in 1840. He married Harriet Stanwood and they had two children together—William B. and Grace S. After the death of his first wife, he married Lusanna Haskell and had two children with her.

In 1867, Daniel Fuller purchased the Knowlton Farm, which encompassed the extent of Magnolia Point. With that, Fuller owned all of the land between Norman Avenue and the water. He then proceeded to lay out roads. He named them Fuller Street, Flume Road, Hesperus Avenue, Shore Road (previously Lobster Lane) and Lexington Avenue.

In 1887, on part of the land he purchased from the Knowlton family, Mr. Fuller built the Hesperus House on Hesperus Avenue, across Lexington Avenue from the Oceanside

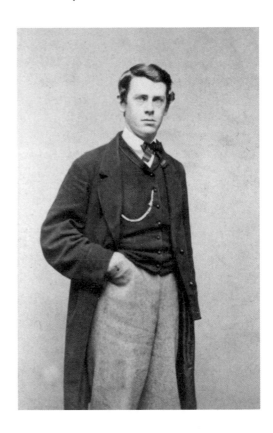

Daniel Fuller. *Magnolia Historical Society*.

Hotel. The Hesperus House was a Queen Anne Victorian. The hotel was extremely popular among Boston visitors, so much so that Fuller built a seventy-foot-long wing and joined it with the main building by a covered walkway. The hotel busted at the seams, with patrons filling its four hundred rooms. Horse-drawn wagons would drop off hotel patrons under the pagoda. In 1886, the weekly rate for the Hesperus House was twelve to twenty-four dollars.

Mrs. Ora Paige ran Fuller's café on the corner of Hesperus Avenue and Fuller Street. Later, the café building was moved and is now Thomas Queeney's house, located at 20 Magnolia Avenue.

In the winter of 1880, after completing the Hesperus House, Fuller went to Leadville, Colorado, with his brother-in-law Thomas Oakes, to visit a friend named Tappan, who owned a silver mine. As Fuller was being hoisted back up from the Deer Lodge shaft, the bucket let go and Fuller plunged 140 feet to his death. A few hours later, Mr. Tappan died from shock.

Fuller's will bequeathed all of his land to his heirs. His remains are buried in Magnolia Cemetery.

Fuller's wife Lusanna carried on running the Hesperus Hotel for many years. In 1884, Lusanna decided that the burden of raising four children, along with running the hotel, was too much for her to handle. She sold the Hesperus Hotel to Ora Paige. Lusanna and her children moved to Wakefield, Massachusetts.

The Hesperus House was sold again after World War II to Mr. Gene Clark, who renamed it the North Shore Inn. The North Shore Inn closed in the early 1950s due to a change in lifestyles. Magnolia was no longer the "grande" place it had once been, and Clark decided it was no longer prosperous to run the inn.

The fire department performed a controlled burn to part of the building and the rest was torn down. The property that was once the majestic hotel was then sold as house lots.

Stanwood Family

Philip Stanwood arrived in Gloucester in 1652. He was dubbed a "goodman." Before he died in 1672, he and his wife Lydia had nine children. Samuel (1657–1726) was a soldier in King Philip's War. He wed Hannah Pres in 1686 and together they had thirteen children.

Their sons John and Philip Stanwood were also granted land for service in the Indian War.

Colonel House

Edward Mandell House was born in Houston, Texas, on July 26, 1858. Throughout his life, he managed many successful gubernatorial campaigns, including those of Charles A. Culbertson, Joseph D. Sayers and S.W.T. Lanham.

He met Woodrow Wilson in November 1911, became his confidant and assisted him in securing the presidential nomination in 1912. In November of that year, Wilson was elected president. Colonel House became Wilson's dearest friend and advisor.

In 1915, Colonel House sailed aboard the *Lusitania* to Europe for his first interview with King George of England. In 1917, House assisted President Woodrow Wilson with the formulation of the "fourteen points." After war was declared in Germany, it was Colonel House who met with Balfour to discuss terms of peace. The next year, House was asked to draft a "covenant of league of Nations" and was appointed to the United States Peace Commission.

House was known as "the president maker," and Roosevelt used flattery to gain his endorsement, thinking House could be an ambassador to the "Wilsonians" in the Democratic Party. House did, in fact, endorse Roosevelt, and the two met regularly at House's home on Coolidge Point during his presidency (1933–1945). The Marble House, built by T. Jefferson Coolidge in 1873, was sometimes referred to as "the summer White House."

James Michael Curley, mayor of Boston and fifty-third governor of Massachusetts (1934), was no stranger to Roosevelt. They met on a train as both were going to a luncheon at the Marble House that would include the Bay State's leading Democrats and liberal Republicans.

Taft and Roosevelt

Both Taft and Roosevelt were friendly with Colonel William Nelson, who was the editor of the *Kansas City Star*. Each was a frequent guest of Nelson at his home, Willowbank. Willowbank is located across from the pier house, with its front door on Fuller Street, and it extends all the way down Hesperus Avenue to Shore Road. The cement garage is located on Shore Road and opens toward the ocean. This was previously the site of the Blynman School building that later became McQuarry horseshoeing.

When Roosevelt was running for president, he would frequently come to Magnolia to consult with Nelson. The men were friendly enough that a special bathtub was built at Willowbank for Taft in the northern bedroom. Taft usually arrived at Magnolia upon the "White Steamer," which brought him to the Kettle Cove Wharf.

Taft is buried in Arlington National Cemetery and Roosevelt is buried on Long Island.

Mason A. Walton: The "Hermit of Ravenswood"

In 1885 Mason A. Walton came to Cape Ann. He lived in Ravenswood Park, located on Western Avenue, for thirty-three years and was dubbed the "Hermit of Ravenswood." A rock with a plaque now stands at the site where his small cottage was once situated.

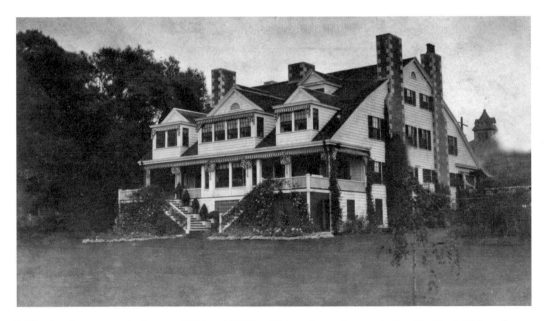

Willowbank was once the home of Colonel William Nelson. It was frequented by Presidents Taft and Roosevelt.

On it are the words:

> *In the cabin near this spot*
> *Mason Walton*
> *"Hermit of Gloucester"*
> *Lover of Nature, Lived for thirty-three years*
> *This tablet placed by the Gloucester Women's Club*
> *1933*

Mason Walton was born on July 31, 1838, to Samuel and Sarah Walton of Old Towne, Maine. Mason had five siblings: Alfred, George, Brainard, Isabella and Angela. He was the quiet but intelligent member of the family. He grew up loving the Maine woods and enjoyed hiking, canoeing, fishing, hunting and camping. A leg injury as a child left him with a slight limp.

Mason was sent to a private four-year prep school at the encouragement of his teacher Helen Hunt. At the academy, he studied botany and ornithology. During the Civil War, Mason lost two of his brothers. One was killed at the Battle of Fair Oakes and the other was lost while serving in the navy.

In 1868, Mason became an enthusiastic editor for *The Greenbacker*, a newsletter for the Greenback Party, which promoted the expansion of paper money issued by the government to finance the Civil War.

In 1870, he married his sister's friend Olive Bradford. Unfortunately, Olive passed away during childbirth in their seventh year of marriage. The baby, a girl, only lived a few hours.

Eventually, Mason became the accountant for a Bangor, Maine pharmaceutical company and was transferred from Maine to Boston in 1880. From living in the city of Boston, Mason developed a severe respiratory infection, chronic allergies and dyspepsia. His doctor advised him to leave the city and go into the woods to try to get rid of his problem. He followed his doctor's orders and spent fifty cents to board the *City of Gloucester* steamer. He arrived at Steamboat Wharf at the bottom of Duncan Street in Gloucester in 1885.

The future hermit arrived with only fruit and a tent. He set up camp at the top of a hill and named it "Bond Hill" (now known as Bond Street). It was here that he naturally nursed himself back to health. Unfortunately, a cold winter storm destroyed Mason's tent and he decided he needed better shelter. He was granted permission from Walter Cressy to build a cabin near Fuller Brook along Old Salem Road. It was then that he decided to dedicate his life to the study of flora, fauna and ornithology. Mason kept a daily journal of his findings and studies of "vernal ponds, vegetative growth, footprints and feathers". Eventually, he made friends with some of the animals and gave them names: Triplefoot, a three-footed fox; Wabbles, a male sparrow; and Bismarck, a red squirrel.

Each day Mason would walk from his home into town to do his errands, collect his mail and get the local newspaper, the *Gloucester Daily News*. He also subscribed to *Field and Stream* magazine. In the late 1880s, Mason became a contributor to the magazine using the name "The Hermit." Letters from all over the world began to fill his mailbox.

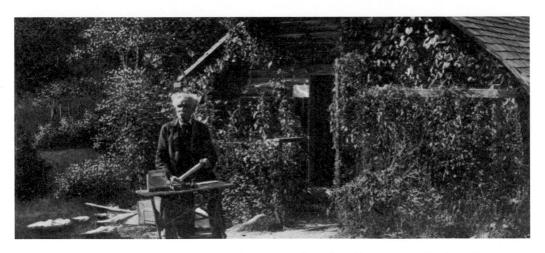

Mason Walton, "the Hermit of Ravenswood," was a botanist and ornithologist who lived for thirty-three years in the woods of Magnolia. *Magnolia Historical Society.*

He conducted field trips for high school students and visitors, and before long, postcards emerged of "The Hermitage," Gloucester, Massachusetts.

In order to make some money, he lectured throughout New England. He traveled to Boston to address the Hale Natural History Club on Annisquam during the ice age. He also made hockey sticks for local ice skaters, sold flowers from his garden and wild magnolias from the swamp. In 1903, Mason wrote a book about his woodland friends called *A Hermit's Wild Friends*. At the end of the day, he always returned to his cabin in the woods.

When the land was named Ravenswood Park, from the gift of Samuel Sawyer, Mason was allowed to remain as the only resident of the park. Thus, he became the "Hermit of Ravenswood." His cabin, which was located on Old Salem Road, made Mason grow in popularity. He offered a wooden bench and a guest book, and for the next twenty years visitors included famous artists, writers, teachers, foreign ministers and wealthy tourists, an average of four thousand people a year. John Hays Hammond Jr. was known to Mason as "that clever young lad who invents such wonderful things."

By 1917, Mason's home was a log cabin, more than twice the size of his first hut. He had a large living room with concrete floors, a stove Hammond had given to him, a cot and a chest of drawers.

After a thirty-three-year Ravenswood residency, Mason became ill at age seventy-nine. His friends, the Homan family, went to check on him one afternoon to find him dazed and confused. A horse-drawn ambulance took Mason to the city hospital, officially called the Alms House. His diagnosis was pneumonia, lung fever and congestion. He died peacefully in his sleep four days later on May 21, 1917. Mayor John Stoddard eulogized the hermit at his funeral. It was then that a plaque was placed on a rock nearby his home as a tribute to his memory. His family arranged for his burial in Alton, Maine, where Mason Augustus Walton lies next to his wife Olive and their baby girl.

In 1948, the hermit's log cabin was destroyed by fire. The plaque that marks the location of his home, along with the memories still remains.

Other Well-Known Magnolia Personalities

Today, any Magnolia native would recognize the names Gilliss, Hines, Hull, Mondello, Sutherland, Rose, Muller, Rogers, Doe, Nolan, Mason, Fiahlo, McCarthy, Ramos, Viera, Peek, Khambaty, Cook, Shatford, Muise, Edmonds and Philpot. Other well-known names from Magnolia include:

Captain Bill Douglas

Douglas was a typical New England seaman. His obituary in the *Gloucester Times* stated:

> He came early in life to begin sailing the sea with his father. His schooling was to be had from the greatest of teachers, life with its hardships, risks, sacrifices. He proved to be an apt student in such a school, for there was formed in him a character as rugged and sound as the body which was its home and a mind keen and capable enough to bring him victory against all the foes of life.

The *Boston Globe* declared:

> His career pretty well covers the course of fishing during the last 65 years. He has gone clamming, lobster trapping, and fishing from Swampscott as a boy, he has fished on the Grand Banks, gone whaling, hunted seals on the Northwest coast, prospected for gold in Alaska, done railroad work in Texas, and finally wound up by lobstering and taking out parties from his place in Magnolia.

Bill had a small shack on Lobster Lane (now Shore Road) and was also well known for his "New England philosophy." Numerous prominent Boston lawyers, bankers and summer visitors of Magnolia have said that Bill was the best cure for "worrisome problems of business, life and what have you."

The Douglases had a son, Colonel Stephen A. Douglas, named for their ancestor who wrote about the iron lung. Captain Douglas spent his last years on a houseboat, much to the displeasure of his family. His wish to die there was granted to him.

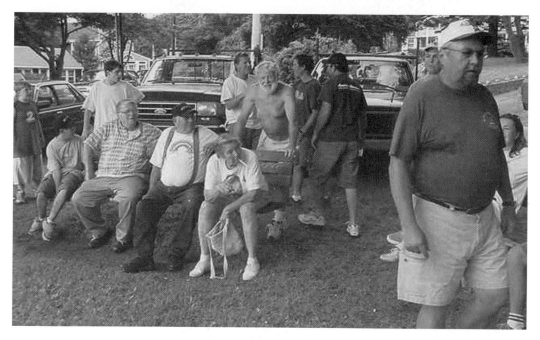

Many well-known Magnolia residents relax at the landing after the Lions Club striper tournament. Hardy and Billy Hull, Paul and Ellen Fiahlo, Bill Rose and George Sherman are among them. *Sandy Peek*.

Martin "Cappy" Burke

Born in Annaghdown, County Galway, Ireland, in 1842, Burke was orphaned at age fifteen. It was then that he boarded a boat to Newburyport, Massachusetts, and joined the navy. The Civil War began a few years later and Burke served on the USS *Canandaigua* during the attack on Charleston, South Carolina.

After the war, he was stationed in Boston and later moved to Magnolia after joining the Gloucester Police Force. In 1887, "Cappy" became the first policeman in Magnolia. He stood in Cole Square under the light (given by Arthur Jones) and directed traffic. He retired in 1918.

Over the years, he became friendly with the locals and later became a legend himself. He was vital in the founding of Saint Joseph's Chapel, where he laid the cornerstone. His daughter Martha Burke taught in Magnolia at Blynman School for over fifty years and his son Jonathan was a prominent Gloucester lawyer. Jonathan served as mayor of Gloucester, and the playground on Magnolia Avenue was endorsed with the Burke name.

Martin "Cappy" Burke passed away in 1922.

Henry West

Henry West, my great-great-grandfather, was born in Frankfort, Maine, in 1862 to Hannah Clark and George West. He arrived in Gloucester at age twenty-two aboard a fishing

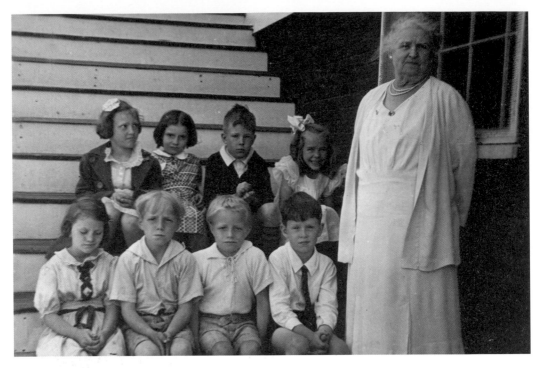

Martha Burke was the teacher at Blynman School for over fifty years. Burke's Field is named after her brother John. *Magnolia Historical Society.*

vessel where he worked as a cook. He first settled in Lanesville and worked in the quarries. It was there that he met and later married my great-great-grandmother, Sarah Morris, daughter of Hannah Daggett and Charles Morris. My great aunts (Lillian, Gertrude and Emma) and great-grandfather (Albert) were born to Henry and Sarah West. When Albert was six months old, the West family moved to a cottage at the end of Englewood Road in Magnolia (now owned by the Clay family). Henry's first job was foreman for the Homan Ice Company, which owned the cottage occupied by the West family. Mr. Homan later sold the business to Cape Pond Ice Company and my great-great-grandfather continued his work under the new name. As Henry got older, he required the assistance of his son Albert.

In later years, Cape Pond Ice Company tore down the last remaining icehouse on Englewood Road and continued the ice business at different, larger locations. At that time, Henry's daughter Gertrude purchased land and built a cottage for her parents at 39 Englewood Road (belonged to Knovak in the 1980s).

Well known in Magnolia for his "little round face, rosy cheeks, chin whiskers" and "sense of humor," his friendly personality made him a well-liked man in the village. It was he who hitched up his *pung* ("sleigh") after a snowstorm and brought groups of people to Gloucester for shopping. One day, with his *pung* well filled, Mr. West let his sense of humor get the best of him and he curbed his horses over the corner and flipped the sleigh. No one was hurt, but "many a fat lady landed on a slim gentleman and vice versa," and all chuckled along with Mr. West.

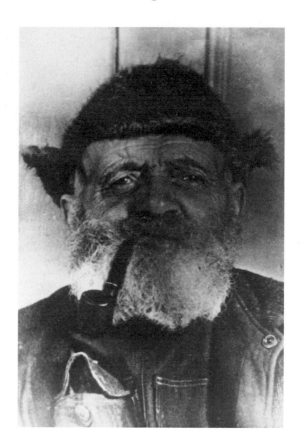

Henry West, grandfather to Frances C. (West) Hines, owned and operated West Pond Ice Company. He was well known for his "little round face, rosy cheeks, chin whiskers" and "sense of humor." *Fran Hines*.

Henry and Sarah celebrated their fiftieth wedding anniversary on November 23, 1937. They lived at their home in Magnolia until death did they part. Sarah died in 1942 and Henry followed in 1947. Both are buried in the Magnolia Cemetery.

Albert West

Born on May 14, 1895, to Henry and Sarah West, my great-grandfather Albert married an Irish woman named Mary Dunning in 1926 and together they had three children—Albert Jr., Frances (Hines) and John.

By 1936, Albert West had saved enough money to purchase the ice business and property from Cape Pond Ice Company. The pond was officially named West Pond at that time. He then built a new icehouse on his family property on the northeasterly side of the pond.

Albert and his family resided at the 41 Englewood Road homestead, which included a large barn on Englewood Road. Living across Lake Road from him, his father Henry was content to ride around the village in his horse-drawn wagon, to cut hay and store it in the barn for the horses. (See more in the section on West Pond in Man-made Wonders.)

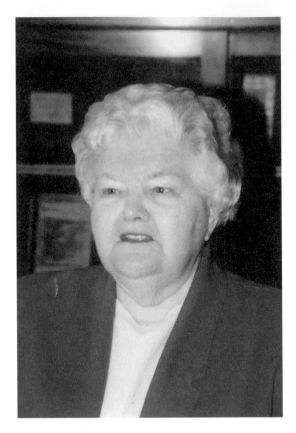

Fran Hines founded the Magnolia Historical Society with her private collection. The historical room at the Magnolia Library Center was dedicated the Fran Hines Historical Room in 2007. *Magnolia Historical Society.*

Albert and Mary West dwelled at the home until they were simply too old to maintain it. They sold the property and moved to an apartment on the third floor of 44 Lexington Avenue in 1976. When Mary died in 1981, Albert moved in with his daughter Fran, who took care of him until he passed on April 12, 1986.

Frances C. Hines

My grandmother, Frances Caroline (West) Hines, granddaughter to Henry West, daughter to Albert and Mary West, was born September 5, 1927, and is a well-known, lifelong resident of Magnolia. She married her childhood sweetheart Paul Hines Jr. and together they raised five daughters: Carol, Sally, Susan, Cyndi and Sandra.

In 1982, Frances founded the Magnolia Historical Society Inc., to educate the public on the grand history of Magnolia. She assembled the museum around her private collection of Magnolia memorabilia and her work on the bibliography of forty-eight historic buildings in Magnolia. In 2007, the board of directors of the Magnolia Library Center Inc., along with distinguished citizens, friends, family and Mayor John Bell, gathered at the Magnolia Library Center to present her with the naming of the historical room as the Fran Hines Historical Room.

In 1984, she was the chairman of Magnolia Heritage Days, and in 1987, she was the chairman of the celebration of the hundredth anniversary of the Magnolia Library.

In addition to being a fantastic and storybook-type of grandmother, she has received numerous awards for her dedicated involvement in neighborhood activities. These awards include: "distinguished citizen of Magnolia"; a House of Representatives Citation in recognition of her involvement in neighborhood activities such as the Girl Scouts, Parent-Teacher Association, Women's Community Club of Magnolia, Magnolia Library Center Inc. and the Magnolia Historical Society; the Commonwealth of Massachusetts Citation from Governor Michael Dukakis for thirty-five years of community service; the Magnolia Library Center "Woman of the Year" Award; the Gloucester City Council Award in recognition of her compassionate commitment to the betterment of the community; and the Gloucester Historic Commission Special Certificate of Recognition for excellence in her contribution to the Magnolia Historical Society.

John Crowningshield

After moving to Magnolia in 1954 John Crowningshield "dedicated his life to preserving the quality of life in Magnolia." An integral part of Magnolia history, he was an original member of the Neighborhood Association. Mr. Crowningshield was influential in convincing the owners of the Oceanside lots not to construct six large, brick buildings like the one at 44 Lexington Avenue. His house on Ocean Avenue is built from the remains of the Hesperus Hotel. He was also a former president of the Magnolia Library Center Inc., the Magnolia Historical Society and the Neighborhood Association.

John Carter

Mr. Carter, a Gloucester teacher for many years, was well known for giving out pencils for Halloween. In his youth, Mr. Carter worked at the Oceanside Hotel for a mere $9.76 a week. He later was instrumental in transferring the Magnolia Library Center into a corporation. He was one of the many residents of this area who put his name and residence on the line to keep the Magnolia Library Center alive. John was also a past president of the Magnolia Library Center. His dedication to the Union Congregational Church was unsurpassed. Although he came across as a subdued man, John actually had a great sense of humor.

Donald Lowe

Mr. Lowe started building houses in 1948. At age seventy-four, he holds the record for building the most homes in Magnolia. As well as two houses for Mr. Krewson, a quick summary of the homes he built were numbers 28, 87, 95, 145, 149, 161, 163 and 215 Hesperus Avenue; and numbers 21, 29 and 30 Flume Road. Many of the homes he built can be found on the

road named after him, Lowe Drive. They include numbers 5, 6, 7, 8, 9, 10, the house next to Sparky Familiari's garage on Western Avenue and the list goes on. His record promoted a major force in building Magnolia from a "dead summer community" into a "suburban bedroom community." Mr. Lowe served as mayor of Gloucester in the 1960s.

Dan Ruberti

Dan Ruberti's house was once Mercy Melville's Gas Station. It was also used as a camping area for summer residents. Today, 555 Western Avenue is a private residence belonging to the well-known and highly visible Dan Ruberti.

The year 2007 will mark the sixteenth campaign for mayor of the city of Gloucester for seventy-two-year-old, ex-marine, salesman, school bus driver and driving-school teacher Ruberti. According to the *Gloucester Daily Times*, this "would-be mayor says he's serious now."

It is always obvious when elections are coming up because one can find Mr. Ruberti out at Tally's Corner, blowing his bugle and handing out bright orange "Ruberti" bumper stickers.

Dan Ruberti always puts a dent in the percentages, but he has never won the campaign for mayor.

Candidates thought they may have jinxed themselves when it was said "Ruberti will be the mayor when the Red Sox win the World Series." The eighty-six-year curse has been broken for the Red Sox, but Ruberti has yet to win.

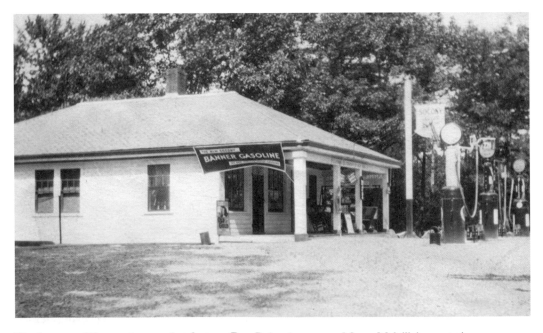

The house on Western Avenue that features Dan Ruberti was once Mercy Melville's gas station.

Fiahlo Family

Paul "Kuck" Fiahlo was born in West Gloucester and moved to Magnolia when he married Ellen Morley. Ellen was born to Austin and Svea Morley. The family lived in the May House and owned and operated the Magnolia Nurseries near Blossom Lane until the mid-1960s, when they opened a flower shop on Lexington Avenue.

Paul and Ellen were married "48 years ago" and purchased the "cheapest house in Magnolia," nestled atop the hill at 49 Magnolia Avenue. At the time, Paul was working for the Sheet Metal Union in Boston, a job he held for about twenty years. After the birth of their three children—Virginia, Rebecca and James—Paul decided to start his own business: Fiahlo Metal Products.

The Fiahlo family has been known for its dedication to the Magnolia community. Kuck joined the Magnolia Lions Club about thirty-five years ago and has volunteered for every fundraising event since that time. His company, "FMP," has sponsored a Magnolia men's softball team for over twenty years now, made the stainless steel box that sealed the contents for the time capsule that was inserted in the Union Chapel in 1984 and has donated a copper boat for the auction at the Magnolia Library Center's fundraiser "Taste of Magnolia" for all thirteen years of its existence. Most often seen with his sidekick of sixteen years, his dog Stanley (or previously, his eleven-year-old friend Fred), Kuck is also well known for his working-man sense of humor. As an entertaining storyteller, Paul recalls the many great days he has had in Magnolia: the Halloween party at the Women's Club on Shore Road, the New Year's Eve parties at the Magnolia Library Center, the Lions Club auctions and George McTigue the "night watchman" of the auction items and the many good neighbors he has.

Shortly after they were married, Ellen started her forty-five-year dedication to the Magnolia Library Center. Ellen not only served on the board of directors for many years, but she also devoted forty-five years as librarian. She was in charge of ordering all of the books for the library and she brought the library into the twentieth century by computerizing the compilation of books. She volunteered thousands of hours to ensuring that the Magnolia Library Center remained functional. In addition to her commitment to the library, Ellen was also involved in the Gloucester High School scholarship committee. Her husband Paul was proud to say that she ensured that "every kid that applied got something." Continuing her leadership in the interest of children, Ellen also served as a Girl Scout leader in Magnolia.

The Magnolia residents and the board of directors at the Magnolia Library Center have chosen to memorialize Ellen for her devotion to the community with a bench in her name to be placed on the Norman Avenue side of the Magnolia Library Center in the spring of 2008.

Their son James, just as well known as his father, continues his family's legacy, serving as president of the Magnolia Lions Club and running the family business. James, full of humor and whimsical stories, can be seen at any community event that promotes the well-being of the neighborhood.

Oldest Living Resident

At the writing of this book, the oldest resident in Magnolia is Mary Ann Cirella at the age of ninety-seven. She and her brother Larry, "Mayor of Magnolia," once operated Mary Ann's Hair Stylist located on Shore Road near Magnolia Square.

Oldest Resident Ever

Anne Smith, born March 2, 1891, resided at Shore Cliff Retirement Home until her death in 2002 at age 111. At that time, she was believed to be the oldest living resident of the Commonwealth of Massachusetts. When she was asked about her secret of longevity, Mrs. Smith replied she "does not know and is actually surprised to have lived so long." She believed "a person should always stay busy and continue to follow politics and the Celtics." In her youth, she taught immigrant children and served as a Red Cross volunteer during World War I. She also helped to nurse the sick during the influenza epidemic of 1918.

Homes, Hotels and Other Buildings

Land was granted at Kettle Cove for service in the Indian War of 1675 to Joseph Clark, Hugh Rowe, Timothy Somes, John Bray, Nathaniel Bray, John Day, Moses Duty, John Finch, John Haskell, Edward Haraden, Isaac Prince, Samuel Stanwood, John Stanwood and Philip Stanwood. Other landowners at Kettle Cove basically made their homes on a piece of land that was "unclaimed." On February 27, 1688, "it was voted at a town meeting that every householder and young man who had attained his majority and was a native of the town, capable of the rights and duties of citizenship, should be granted 6 acres of land." There were thirty-one lots laid in West Gloucester and Magnolia. These lots were granted to Thomas Bray and his son Thomas, John Clark, Peter Coffin, Nathaniel Coit, Richard Dolliver, Jacob Davis, James Davis, Richard Dike, Timothy Day, William Haskell and his son William, Benjamin Haskell, Joseph Haskell, Mark Lufkin Jr., Nathaniel Millett, John Pulcifer, Thomas Penney, John Sargent, James Sawyer, Henry Walker, Reverend John Wise of Chebaco and Humphrey Woodbury. By reading these names, one can appreciate the labels we still use on some of our streets, creeks, ponds, meadows, beaches and peninsulas.

Fourteen Original Homes

In the year 1838 there were fourteen houses in Magnolia; all but the Knowlton Farmhouse are still standing:

1. Number 114 Magnolia Avenue was once known as the Briggs House, and was later owned by the Morgan family. This house has been recently renovated and is owned by Michelle Brooks.
2. Located at 111 Magnolia Avenue, this house was once known as Dan Casey's Blacksmith Shop.
3. Located at 93 Magnolia Avenue, this was once known as John McKay's House. This house is now owned by Mark and Maureen Gedney.
4. Located at the four corners of Magnolia Avenue and Western Avenue, this house has had many names, including Magnolia House, Stanley Tavern, Addison Gilbert House and House of Color. This house was the first to use the name Magnolia. In the mid-

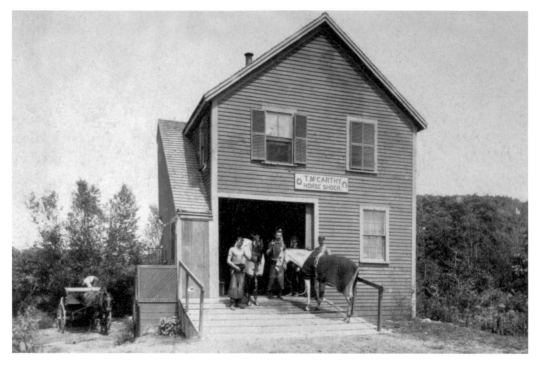

Located at 111 Magnolia Avenue, this house was once Dan Casey's Blacksmith Shop, then T.M. McCarthy Horseshoer and is now a private residence.

1900s, the large white house at the head of Magnolia Avenue was the main building in Magnolia. It was later used as a country tavern and was a popular stopping place for travelers and stages making the trip between Salem and Gloucester. This house at one time had a wraparound porch. Fighters from the Civil War had seen these porches in the South, and upon their return, many built similar porches on their homes.

5. Located at 745 Western Avenue, this house, which now belongs to the Neves family, was once known as Dr. Dakon's House, Laurel Tea Room, Story House and Tekla May House.

6. Located at 751 Western Avenue, this house was built in 1704 by Gilbert Story. Other owners included Nathaniel Millett and the Kairalla family.

7. Located across Magnolia Avenue from the Addison Gilbert House, at 727 Western Avenue, is the Anderson House.

8. Located at 632 Western Avenue, the May House was built in 1765. The front door faces away from the main street, as Old Salem Road used to pass on the other side of the house.

9. Located at 61 Shore Road, the Ben Adams Cottage was the first place summer visitors stayed in tents.

10. Located at 25 Magnolia Avenue, the McPeck House, also known as the Trowt House Cottage, was once sold to Oliver Honors in 1811 without mention of the building. John Knight purchased the property with the building in 1846 for the sum of thirty dollars.

Located at 745 Western Avenue, this house once belonged to the traveling medicine man Dr. Dakon. It was later known as the Tekla May House and the Laurel Tea Room, circa 2005.

The Anderson House is on the corner across Magnolia Avenue from the Addison Gilbert House, circa 2005.

It is a small white house, with a white picket fence, set back from the road, although it is still closer than the Oak Grove House to Magnolia Avenue.

11. Located at 31 Fuller Street is the McCarthy House.

12. Located at 68 Magnolia Avenue, the Solomon Burnham House is now a duplex. The land was originally that of Benjamin Gilbert, handed down to Samuel Gilbert and then sold to Solomon Burnham who built the home that was later turned to face Magnolia Avenue.

13. Located at 6 Fuller Lane near the fire station, the Fuller Lane House was also owned by the Knowltons at one time. It is said that this house was used as a personal laundromat at one time.

14. The Knowlton Farmhouse was originally on Magnolia Point. This house is the only one of the fourteen original homes that is no longer standing.

Captain Ben Adams Cottage

Captain Benjamin Adams built his house on land he purchased in 1846 for the sum of twenty dollars from Marnett Knowlton and John Knight. The address was 1 Magnolia Avenue. This house is still at its original location, but the address is now 61 Shore Road. The address change was caused by the way Daniel Fuller named the streets *after* Ben Adams had purchased his house.

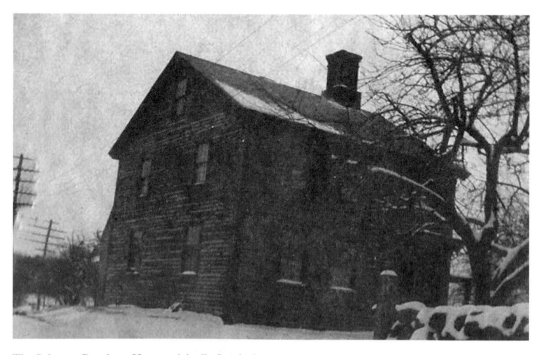

The Solomon Burnham House originally faced what are now the soccer fields on Magnolia Avenue. *Magnolia Historical Society.*

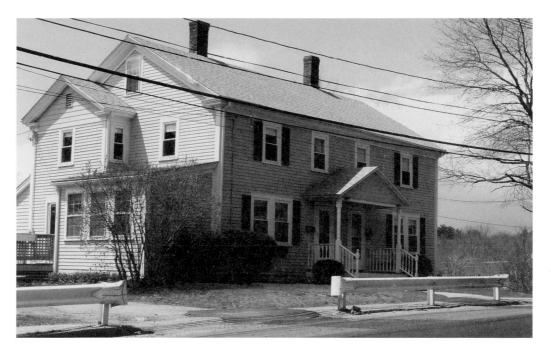

The Solomon Burnham House faces Magnolia Avenue as a duplex.

Mr. Adams owned a fish business, employing some thirty men at a time. In his business, Mr. Adams needed a lot of rope, most of which he purchased from the Boston firm of Sewall, Day and Company. Samuel Day, a twine man and part owner of the company, was the first of many visitors to Kettle Cove. He came to see Captain Benjamin Adams and to go recreational fishing. Mr. Day became so charmed with Kettle Cove that he asked Ben Adams if he could bring his wife and family to spend the summer. The word spread quickly through Boston about how beautiful Kettle Cove was, and as a result, many visitors started to arrive.

The first summer visitors to Magnolia arrived from Boston in 1861 and stayed in tents. In 1872, the Ben Adams Cottage was the first "real hotel" in Kettle Cove where guests stayed inside the house.

After Adams's death in 1884, the cottage was inherited by his daughter Glammy Foster. She leased the property to a store that sold items from the Orient. In 1920, after many years in business, the store closed. The building remained vacant for twenty years, as it was too expensive for Glammy to recondition the house. In the 1940s it was purchased by Wilfred and Marion Ringer. Their only son was killed in World War II. The Ringers used the money from GI Life Insurance to purchase the home and turned it into a summer house. Mr. Ringer had worked as the principal of both Brookline and Gloucester High Schools. Mr. Ringer died in 1950.

Bill and Nancy Edmonds purchased the home in the late 1960s. After more than thirty years of residence, they sold the cottage to Barbara and Mike Markell in 1993. Ironically, Mike Markell was a student at Brookline High School when Mr. Ringer was

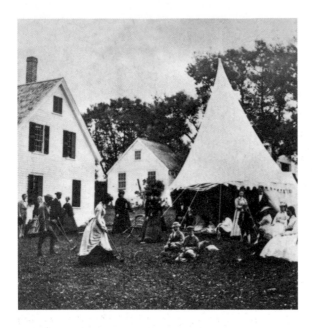

In 1861, visitors from Boston "tented" at the Ben Adams Cottage. The address at that time was 1 Magnolia Avenue. *Magnolia Historical Society*.

the principal. The Markells have again renovated the Ben Adams Cottage. During renovations, they found many fabulous artifacts, including a newspaper from the 1800s, an oriental fan (most likely from the store), a button, some shoes and a picture of "people playing croquet under fluted white tents" that was shot sometime in the 1860s. These artifacts are available for viewing at the Magnolia Historical Society.

In the late 1800s, tax records show the Ben Adams Cottage was valued at $393. Tax records of 2005 indicate the house was worth $536,400.

Addison Gilbert House/Stagecoach Inn/House of Color/ Stanley House/Magnolia House

In 1838, as the Stagecoach Inn, this cottage was the principal building in Kettle Cove. It was the stopping place for stagecoaches running between Salem and Gloucester.

After 1876, it was "used as a country tavern" and named the Magnolia House. As stated, this was the first time anything in the area was honored with the name Magnolia.

A little more than a half century ago, the large house at the head of Magnolia Avenue was occupied by Rufus Stanley, hence the names Stanley House and Stanley's Corner (now known as Four Corners). The house soon after became the House of Color in the 1930s. The inn provided guests with the whimsy of every room being a different color.

Over the years, the house has been through times of profound evolution, including the addition and then the removal of a wraparound porch. The house remained empty for a number of years after the House of Color closed. The Addison Gilbert House remains a residential property and is now owned by the Holden family.

The Ben Adams Cottage acquired its present address at 61 Shore Road when Daniel Fuller renamed the streets after Ben Adams bought the house, circa 2005.

In 1838, this house was known as the Stagecoach Inn. Throughout the years it has also been called the Magnolia House, the Stanley House, the House of Color and the Addison Gilbert House.

May House

Jonathan May came to Kettle Cove from England as a "jack of all trades." He was a contractor, a builder and the first real estate agent in the area. His office was located on Shore Road in one of the many buildings that lined the ocean side of the street near the pier. In the summer, he built such homes as the Oak Grove Inn, the C.C. Goodwin House and a section of the Oceanside. During the winter months, he would change his service to that of caretaker of summer homes.

May once owned one of the oldest houses in Magnolia. According to history, this house was built in 1765 and had many owners before May. The over two-hundred-year-old house is still located on Western Avenue near the Four Corners (the red one that sits sideways to Western Avenue at number 632). Old Salem Road first made its way in front of the May House, until Route 127 was established to direct vehicles around the back of the house—hence the reason it looks like it sits sideways to the main road.

The land alone was first owned by James Weber, who sold it in 1765 to blacksmith Christopher Hodgkins. Mr. Hodgkins built the house that sits upon the land. In 1801, the estate was purchased by Thomas Knight. It was then sold in 1802 to a man by the name of Aaron Winship for the sum of $1,300.00. John Honnors Sr. bought it from Winship, who in turn left it to his family upon his death. James Knowlton then purchased the estate in 1844, from the Honnors family, for $956.30. Later that year, a man by the

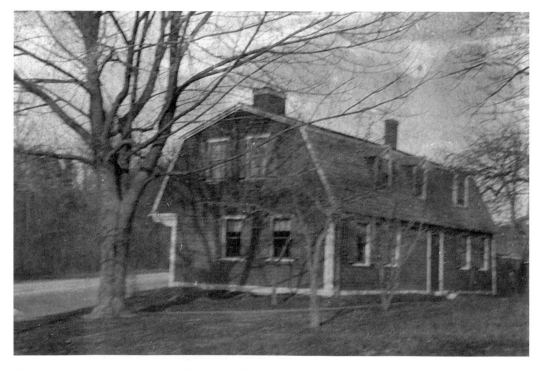

The May House, when located on Old Salem Path, had its door on the "right" side. *Magnolia Historical Society.*

name of Adams cleared the mortgage of $250.00. Felton purchased it from Adams for the sum of $600.00. Felton then sold it to Burnham for $500.00. George Crispin bought it from Burnham in 1855 for $650.00. Lorenzo Dow Story acquired the estate in 1864.

Mr. Story operated a grocery store and post office across the street from the home. Jonathan May married Lorenzo Story's daughter Florence on June 12, 1875, and in 1884, the property was handed down to them. The Mays had six children: Ethel, John, Marjorie, Abbie, Florence and Jonathan.

Son John May married Tekla Hernquist, who was the owner of many Laurel Tea Rooms in Magnolia. Judy Dunbar was Tekla's sister. (Do you remember Judy's home-made coffee rolls at the Breakfast Nook? If not, just know they were notable enough to go down in history!)

John and Tekla had two daughters, Agnes and Florence. Agnes May Ernst resided in Magnolia on Englewood Road until November 2007, when she passed away at the ripe age of ninety-four. She was one of the originators of the Women's Community Club of Magnolia. She was also one of the sweetest ladies in town.

The elder Jonathan May died at the ripe old age of seventy-eight and is buried in Magnolia Cemetery. The May House at 632 Western Avenue is now owned by Alberto and Christy Rosso.

Kairalla/Story House

On land originally granted to Blynman, then purchased by Thomas Millett, this property at 751 Western Avenue was situated near Manchester, where Millett became

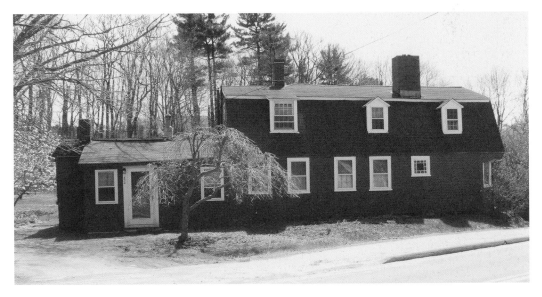

The May House, located on the same lot, but with an address of 632 Western Avenue. The door is on the "wrong" side, as Old Salem Path used to pass along the other side of the building, circa 2005.

a resident. The property transferred from Millett to Gilbert, and then to Knowlton, to Story, to Foster and, in 1930, to Kairalla.

Legend has it that this house was built in 1704 by one of the young men in the village, possibly John Gilbert, for his bride. Rumor has it that the couple did not live happily together and the wife eventually left her husband. The house was then rented to another couple who only stayed a short time, because they believed the house was haunted. They stated that they had seen a white face pressed against the windows at night. For many years the house remained unoccupied, until another young couple came to live there. The couple seemed to enjoy the house and were quite prosperous in their business. Years passed and the couple's eldest daughter was married. Soon after, in the fall of that same year, the woman's mother died. The mother was laid to rest in Magnolia Cemetery. It is believed that it is she whose stone bears the single word "Mother," although it has not been proven.

It was then that the belief in the haunted house was renewed. The next spring, the entire family moved from the house. The haunted house remained empty for many years. When it was eventually sold, the curse seemed to be removed and many have lived and loved there since.

Charles C. Goodwin House

The first summer, single-family residence was built by Charles C. Goodwin on land at the corner of Lexington Avenue and Shore Road. The house was moved on rollers in the 1880s to its new location at 26 Flume Road.

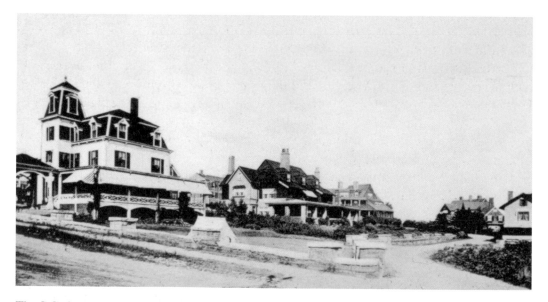

The C.C. Goodwin House on the corner of Shore Road and Lexington Avenue before it was moved to Flume Road. *Magnolia Historical Society*.

The C.C. Goodwin House at its present location at 26 Flume Road in the year 2005.

The Oceanside Hotel

In 1876, Daniel Fuller sold a quantity of his property to Mr. and Mrs. James Perkins. That same year, they began to build the Perkins House, a boardinghouse for summer guests. The project was completed and opened for business in 1877. The Perkins family resided in half of the house, while their guests inhabited the other half.

A short two years later, in 1879, George Upton purchased the Perkins House. He built it upward and outward and moved the front entrance from Lexington Avenue to Hesperus Avenue. In 1880 upon completion of the reformation, he changed the name to the Oceanside Hotel. In the years to come, Upton would continue to build the three-story, rooming house cottage into a six-story building that encompassed the entire block of Lexington Avenue and Hesperus Avenue.

As he built, Upton also purchased "cottages" to expand the grandeur of the hotel. Upton owned five cottages in a row located behind the hotel on Flume Road. He named them East, Flume, Perkins, Highland and The Breakers. The cottages alone could accommodate over five hundred guests. When the Oceanside Hotel experienced overload, the Seaview Cottage was used to accommodate more guests. Today, Seaview Cottage can be found on Boulder Avenue as a private home. It can be viewed from Shore Road. As you drive down the hill near the end of Shore Road, look to the left just as you reach the bottom of the hill—the home that stands regally over the harbor from a distance is Seaview Cottage.

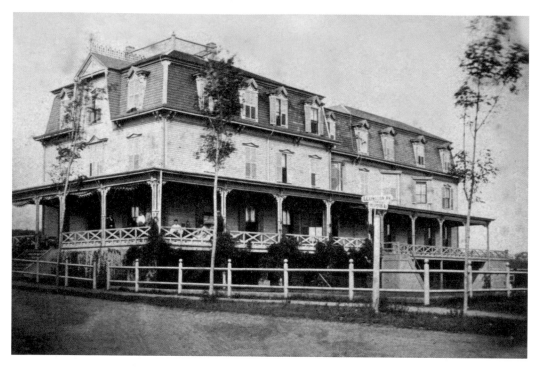

Mr. and Mrs. James Perkins operated the Perkins House until George Upton bought it in 1879 and changed the name to the Oceanside Hotel. *Magnolia Historical Society.*

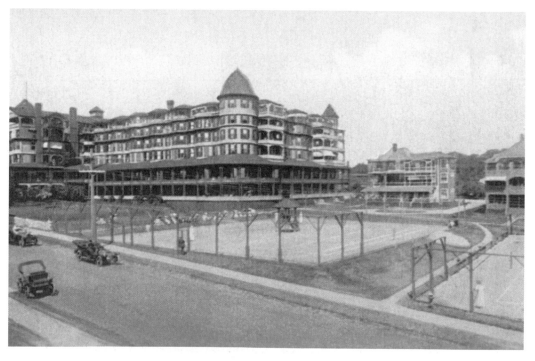

A view of the Oceanside Hotel and the "cottages." *Magnolia Historical Society.*

Guests vacationing at the Oceanside Hotel often brought along their household staff of maids, chauffeurs, cooks, butlers and other servants and housed them in nearby dormitories to ensure their every need was catered to in the manner to which they were accustomed at home. Personal servants for the hotel guests usually stayed at the Men's Club.

The Oceanside Hotel was one of the finest hotels in the region. It was also the largest wooden structure in the northeast United States. It was large enough to boast a theater that housed over four hundred guests. Famous in its own right, each week the Oceanside Hotel hosted actors and actresses from New York, including Clara Kimball, Ethel Barrymore and Maude Adams, for plays and musicals. The Oceanside had a multitude of activities in which to engage and a panoramic view of the ocean. Housed within the hotel grounds were also a grand lobby, a casino, immaculate tennis courts, a sizeable pool, numerous jewelry and dress shops, a barber, a beauty shop, elaborate formal tea gardens, the most impressive dining establishments and a music and ballroom. Upton also leased a bathing pavilion at the beach for those who wanted to enjoy sun and fun in the sand.

In 1886, the rate for a week's stay at the Oceanside Hotel ranged from twelve dollars to twenty-four dollars.

In the 1900s, in order to meet the demands of his thriving business, Upton used the Hesperus House as an extension of the Oceanside. With its numerous dormitories, cottages and hotel rooms (exceeding a thousand in number), the Oceanside Hotel was

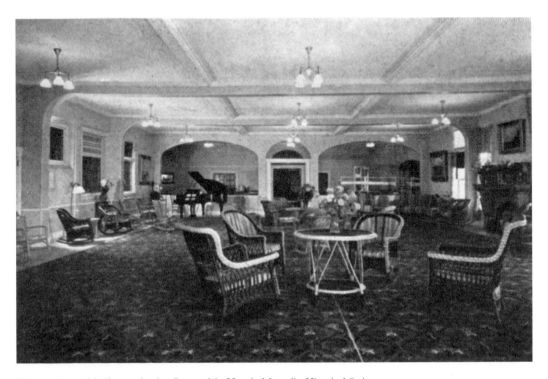

The music and ballroom in the Oceanside Hotel. *Magnolia Historical Society*.

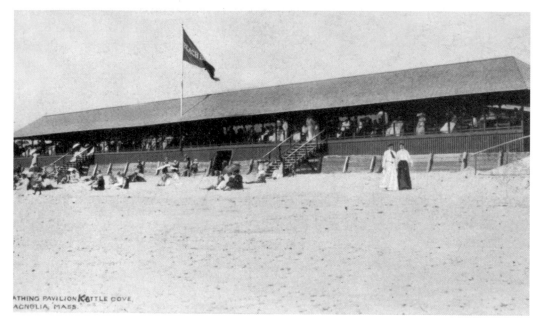

The bathing pavilion for the Oceanside Hotel, once located on Magnolia Beach.

dubbed "the biggest hotel east of the Mississippi" and was capable of accommodating up to three thousand guests a night.

Totally self-sufficient, the Oceanside generated its own electricity, made its own ice and burned six tons of coal daily. A luxury at the time, the hotel had telephone service to Davis's stable for horse and carriage rentals, repairs and boarding.

A bit of trivia reveals that the famous Davis Cup tennis competition was played at the Oceanside in 1912. The register for the Oceanside Hotel weighs over thirty pounds and has been preserved at the Magnolia Historical Society Inc. Renowned guest Rose Kennedy registered at the Oceanside Hotel in 1942. Other significant visitors included J.P. Morgan; the Lambert family (Listerine); H.J. Heinz and John Philip Sousa; John Anderson, chief counsel to Henry Ford; Cecil Rhodes; and General MacArthur.

George Krewson purchased the Oceanside from George Upton in 1927. That same year, the Oceanside Hotel had its first fire. Firefighter Guy Symonds, age thirty-seven, collapsed and died during the fire while running to get a ladder. The small fire was eventually put out and business was continued shortly thereafter.

Oceanside owner George Krewson's brother was so enthralled by Magnolia that he wrote two semifamous poems about Magnolia: "Moonlight in Magnolia" and "Magnolia, Mass." Krewson sold the hotel to a Mr. Snyder, who was the owner when it burned to the ground in 1958.

On the coldest night of the year, December 11, 1958, the largest wood structure on the northeast border of the United States, the Oceanside Hotel, burned to the ground. The hotel happened to be closed for the season at the time of the fire. The exact cause of the great fire is unknown, but it is known that it began in the kitchen late at night. The

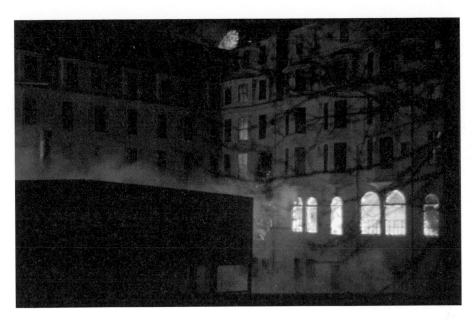

The Oceanside Hotel burned to the ground on the coldest night of the year, December 11, 1958. *Magnolia Historical Society*.

entire structure was ablaze for many hours and eventually burned entirely to the ground. Sally Peek remembers, "It looked like the whole world was on fire." In the end, all that was left standing was the chimney. Three of the cottages survived the fire, but two were so badly charred they had to be torn down. Shatford's house at 18 Flume Road is the only cottage that remains standing today.

Not many articles were salvaged from the fire. The Magnolia Historical Society does have some silverware, cups and saucers, and one of the hotel register books from before the fire.

In 1960, a Beverly Farms leather merchant, Herbert Kaiser, purchased the land that had been formally occupied by the Oceanside Hotel, along with the other properties of the Oceanside Corporation. The sale included four acres of land, two three-story buildings, a swimming pool, a tennis court, a twelve-room apartment cottage on Flume Road and two properties of 39,000 square feet on Raymond Street, in Manchester, with 175-foot frontage on Gray Beach containing a bath house, as well as two other buildings across Lexington Avenue, for the mere sum of $125,000. Kaiser had originally planned to build six one- and two-bedroom apartment buildings, much like the one at 44 Lexington Avenue, but the Neighborhood Association was helpful in putting a stop to that plan.

In 1974, the Magnolia Pool Association, a group of Magnolia residents, purchased the tennis courts and swimming pool that were once part of the Oceanside landscape. Yearly dues were used to maintain the grounds and provide lifeguard duty. The endeavor, however, was sold in the 1980s as residential land.

Three large homes now reside on the former grounds of the tennis court and pool at 209–213 Hesperus Avenue. The area that once housed the grand extravagance of the

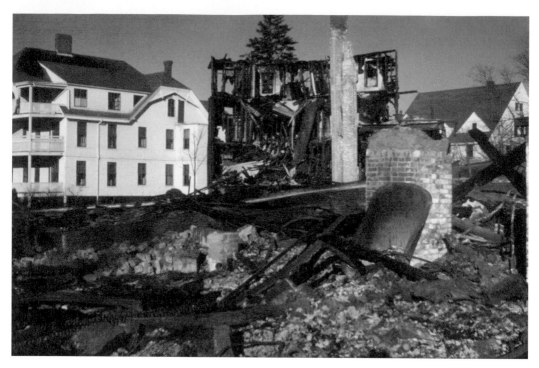

Remains of the Oceanside inferno. Shatford's house at 18 Flume Road (rear of picture), a dormitory for the Oceanside servants, was the only Oceanside property to escape the blaze. *Magnolia Historical Society*.

The Oceanside area as the Magnolia pool and tennis courts. This picture was taken from the large brick building at 44 Lexington Avenue, circa 1977. *Magnolia Historical Society*.

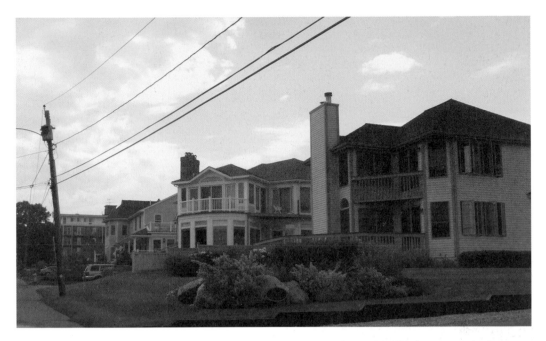

The lots that once embraced the tennis courts and gardens of the Oceanside Hotel now contain three large, private homes. *Magnolia Historical Society*.

Oceanside Hotel is now a square brick building at 44 Lexington Avenue and twenty-two other nearby structures. The Oceanside bathing pavilion is now that of the Kettle Cove Condominiums, located on Raymond Street in Manchester with views of Magnolia Beach.

The Willow Cottage

It has been said that the house was originally built at a location on "upper Magnolia Avenue" by Scipio Dalton. It was purchased by James and Nancy Knowlton and then moved to its location between what are now numbers 3 and 5 Magnolia Avenue. In 1876, it was inherited by their daughter and her husband, Bernard Stanwood, who converted it into the Willow Cottage.

The entrance to the Willow Cottage was fenced with the bones of a stranded whale. In 1886, the weekly rate to stay was seven to fifteen dollars. William Morris Hunt taught art classes at the Willow Cottage beginning in 1877; this noteworthy landscape artist summered in Magnolia in his later years. Other notables who stayed at the Willow Cottage include Louisa May Alcott, author of the book *Little Women*, and Edward Everett Hale, who wrote the book *Man Without a Country*.

The Willow Cottage building was eventually bought by George Upton, who moved it to Oceanside property. He raised the building two stories and used it to house the female "help."

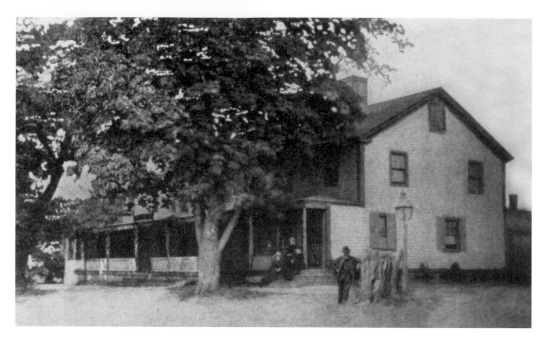

The Willow Cottage, home to famous artist William Morris Hunt, was once fenced with the bones of a stranded whale. *Magnolia Historical Society*.

William Morris Hunt

William Morris Hunt was born in Brattleboro, Vermont, on March 31, 1824. Hunt moved to New Haven, Connecticut, with his mother and brother in 1832, when he was eight years old. The first art lessons he received were from an Italian artist boarder who stayed at Hunt's mother's house. William Morris Hunt was greatly influenced by the Barbizon school and artists Thomas Couture and J.F. Millet. During the Civil War, he moved to Boston and introduced the ideals and methods of the Barbizon school to the city. Hunt began painting figures, later turned to portraits and then, in his older age, dedicated himself to painting landscapes. In 1872, Hunt lost his Boston studio and most of his work in the "great fire."

It was then that Hunt moved to the "sea-cooled" Magnolia by invitation of architect William Ralph Emerson, who owned a small cottage near the beach. Hunt purchased a barn from Stanwood, across from the Willow Cottage where he resided. His brother, famous architect Richard Morris Hunt, designed "the hulk." This pagoda, where he did his painting, was located on top of a pole that suspended Hunt in isolation. Hunt fixed a sundial on the wall with a sign that declared: "Now is the time."

Mr. Hunt taught art classes to residents and visitors of Magnolia from his studio at the base of "the hulk." It was said that when he traveled the roads of Magnolia to paint, he would often wear a sandwich board that stated, "I can't talk and I can't hear." The artist painted many pictures of Magnolia during the brief period of time he was here. Many of his works are in major museums around the world. The William Morris Hunt Library is located at the Museum of Fine Arts in Boston.

In 1879, Hunt was extremely busy with "work." It was then that he went to the Isle of Shoals in New Hampshire to "rest." His body was found in a tidal pool—accident or suicide? It was never determined.

The Aborn

Mr. Aborn built his hotel in 1899. He was originally from Wakefield, Massachusetts. The sizeable hotel was located on Lexington Avenue, just beyond the corner of Oakes Avenue. The hotel was managed by Henry Haskell, a son-in-law of Mr. Aborn.

The hotel suffered financial demise. Annie Ryan purchased two cottages from The Aborn and had them floated across the water, hauled onto the beach and then moved to Raymond Street. The cottages are now known as Kettle Cove Condominiums.

The main hotel building was used as a private home of the Davis family for many years until it was eventually torn down.

New Magnolia Hotel

The New Magnolia was built in 1891 by Reverend Frank Sprague and was located on the corner of Lexington Avenue and Flume Road (where J.D. and Myers Best Friends

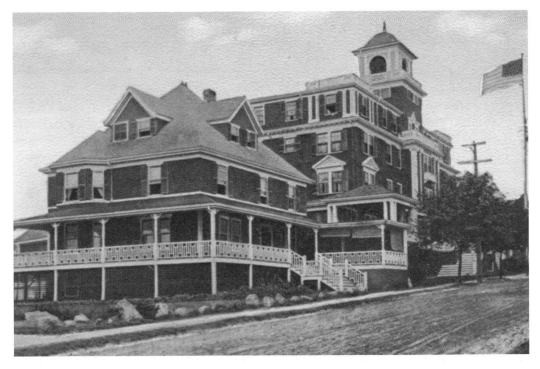

The Aborn was located on Lexington Avenue, just beyond Oakes Avenue. *Magnolia Historical Society.*

Inc., also known as the Magnolia Pub, stands today). Later, the hotel was sold to a consortium and was managed by a Mr. Gibson, a "popular hotel man."

The New Magnolia Hotel was judged as one of the "most beautifully located and satisfactory conducted" hotels of the North Shore resorts. Perched at the highest point in Magnolia, the New Magnolia was "a skyscraper in its day." It was arranged that nearly every one of the four hundred rooms in the New Magnolia had an ocean view and a spacious piazza.

Music was always supplied by the New Magnolia Orchestra, a feature that greeted and pleased all of the guests. For those who enjoyed sporting, tennis and croquet grounds were available at the hotel.

After only seventeen years in business, the New Magnolia Hotel was destroyed by fire in 1908. At that time, the New Magnolia Hotel Corporation was dissolved.

In 1915, entrepreneur Annie Ryan purchased the lot of the former New Magnolia Hotel between the Colonnade and the Oceanside Hotel. She then constructed nine elegant stores on Lexington Avenue.

As you will see later, this same lot burned again in 1991 and yet again in 2002.

Oak Grove House

The Oak Grove House was built in 1877 at 29 Magnolia Avenue by Mr. and Mrs. Bernard Hunt. As one of many summer guest homes, it received its name from the

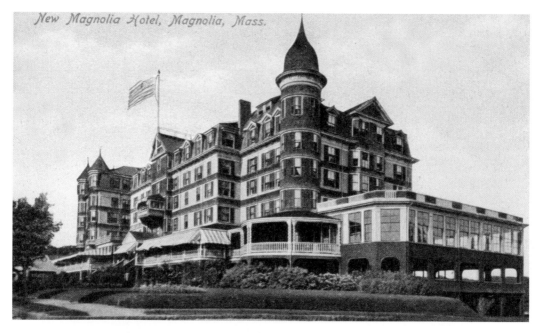

The New Magnolia Hotel was built in 1891 and destroyed by fire in 1908. The Magnolia Pub is now situated on the land where this majestic hotel once stood. *Magnolia Historical Society*.

large grove of oak trees at the rear of the house. It was often referred to as "Old Ladies Home," because elderly ladies favored staying there.

In the 1930s, it was converted into a private residence and has since been converted into apartments.

Brown Gables/Green Gables

The earliest deed found in regards to the entire property was in 1879 when Alonzo V. Lynde sold the land on the corner of Fuller Street and Hesperus Avenue to Daniel W. Fuller.

The structure of Green Gables was built in 1929 and later owned by James Groves of Field Road. The Green Gables building was used as a hotel for single ladies, and the Brown Gables cottage next to it was used for the employees of the inn.

Green Gables was a three-story building, with sixteen rooms, ten bathrooms, six open fireplaces and a steam plant for heating. The basement housed the laundry, kitchen, storage rooms and servants' quarters. Yes, the hotel and gables were green. A much-liked, longtime resident of Magnolia, Eleanor Benotti, arrived in Magnolia when her father was a chef at Green Gables.

In July of 1924, the property was sold at auction. Sarah M. Kelly bought the property and operated the hotel until her death in 1934 at the young age of thirty-five. From 1934 until 1959, the property had six owners and four names.

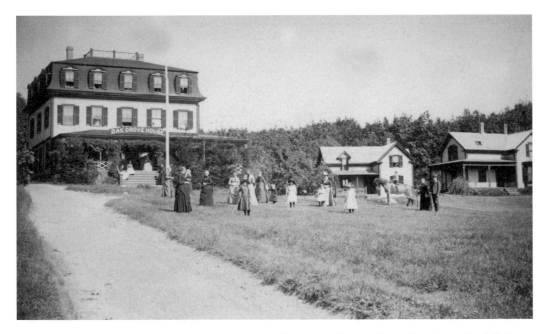

The Oak Grove House was built in 1877 at 29 Magnolia Avenue. It was often referred to as the "Old Ladies Home," as old ladies favored staying there. *Magnolia Historical Society*.

Then, in 1959, a fire destroyed the Green Gables Hotel, but the Brown Gables Cottage remained intact. The hotel was replaced by a multi-unit apartment building that also suffered a fire in the 1970s. The complex that sits upon the grounds of what use to be Green Gables is now owned by Mr. McCarthy and is currently being sold as condominium units.

Brown Gables Cottage was purchased by Mario Furtado, a graphic designer, in December 1995. He has made many attractive renovations to his residence since then.

Magnolia Library Center Inc.

The first actual library was located in a room at the Union Chapel on Flume Road. The original idea to build a new library building and meeting place was formed in 1884 by O.A. Richardson, Colonel Thornton, Arthur Jones and Oceanside Hotel owner George Upton. On December 11, 1886, a nonprofit corporation was created to be known as the Magnolia Library Association. The group of twenty-five shareholders purchased land on the corner of Lexington Avenue and Norman Avenue from William and Grace Fuller, the children of Daniel Fuller, in 1886 for $675.

The corporation commissioned Charles Cummings, a well-known architect from Boston, who designed such buildings as the Old South Church in Boston, to develop

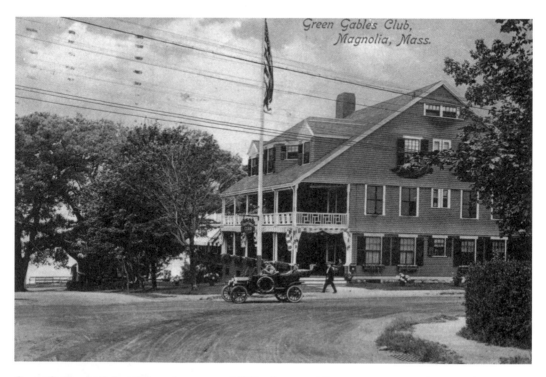

Green Gables, built in 1929 on the corner of Fuller Street and Hesperus Avenue, was a hotel for "single ladies." *Magnolia Historical Society*.

This private home was once Brown Gables.

a structure to serve as a library and place for social gatherings to be known as the Magnolia Library Association. Cummings also designed the H.C. Bull Cottage on the corner of Lexington and Hesperus Avenue and the Union Chapel on Flume Road.

Mr. Cummings and his family lived in the home he designed at 5 Englewood Road (up the first driveway on the right from the Magnolia Avenue entrance sits the house on a hill). In 1887, the building plans for the architectural design of a Queen Anne English Tudor, with cross gable design, were completed. The construction of the building was completed in 1891.

Miss Alice Story was the first librarian, and she spent much of her time reading to the young people by kerosene lamp. In 1893, the board voted to have electric lights installed.

The shareholders then sold stock in the library for twenty-five dollars per share. The profits from the stocks sold were *always* to be used for the purpose of their original mission statement: "establish, maintain a library, reading room and a place for social gatherings, and to promote the instruction, comfort and pleasure of the residents of Magnolia and other parties associated or connected with them." For many years, the center was governed by the original shareholders of the property. The Magnolia Library Center once had its main entrance as a large veranda on the Norman Avenue side, with a second-story porch on the Lexington Avenue side. Ms. Helfridge had mannequins displaying wares for her dress shop on the second story next to her small living quarters on the same floor. Mr. Latassa made clothes in the room that now houses the children's

The Magnolia Library was built in 1891 on the corner of Norman and Lexington Avenues. At that time it was owned by stockholders. *Magnolia Historical Society*.

library. The library of books was located in what are now the Lexington Avenue entranceway and the men's room. With time, the porches were enclosed to make room for the kitchen and the Richardson Suite. The cupola atop the library was removed in 1969 with renovation.

Over time, many of the original shareholders passed away. Interest in the Library Center lessened, and it suffered a period of depression for many years as it fell into disrepair. In the 1960s, a renewed interest came in and the Friends of the Magnolia Library was formed.

In 1968 the Friends of the Magnolia Library approached the last remaining shareholder, Mr. Arthur Jones, asking him to turn over his shares to the Magnolia residents. An agreement was reached and an open meeting of the residents of Magnolia elected a new board of directors. Robert Dryer, Abdullah Khambaty, John Carter, Desmond Sullivan, George Swanson, Ed Lowe, Nancy Edmonds, Frances Hines and Patricia Williams made up the first official board of directors in 1969 under the corporation name of the Magnolia Library Center Inc. Under the management of the new corporation, a new set of bylaws was established. In order to renovate the Magnolia Library Center, some twenty Magnolia residents put their own names on the line and took a mortgage to provide the much-needed $63,000 renovations. They worked diligently to carry out extensive fundraising activities to assist with the mortgage repayment.

The Magnolia Library celebrates a hundred years. The center is totally dependant on the Magnolia community for support. *Magnolia Historical Society*.

The Magnolia Library Center Inc. offers no stock—the membership owns the equity of the corporation. The center also receives no assistance from the City of Gloucester; it is totally dependant on the Magnolia community for support. The money is raised as follows: membership, donations and profits from special events, hall rentals, the Magnolia Art Festival, the Taste of Magnolia, the Magnolia Road Race and the Magnolia Memorial Walkway.

For almost forty years, the varied volunteer board of directors, which is elected by the members, has worked tirelessly, along with the 247 members, to raise money to keep the building functioning and updated. The current board of directors includes President Michele Brooks, Secretary Donna Kecyk, Treasurer Tim Philpott and members Kristin (Baughn) Rattray, Joe Molnar, Cathy Lake, Noeline Kohr, Paul Movalli and myself.

The rooms in the library have been dedicated to significant Magnolia residents. Jones Hall was named in recognition of Mr. Arthur Jones for service performed in the community. The Richardson Suite was named in honor of Mr. E.C. Richardson, who was the first president of the Magnolia Library and the prime moving force behind it when it was formed in 1886. The library room was named after John Benotti, a local resident, who spent much time and effort in maintaining the library as an ongoing force in Magnolia. The Fran Hines Historical Room is named after Frances C. Hines, who founded it and provided a plethora of artifacts from her private collection to the museum.

Although it may not be a popular pastime today, with the introduction of the Internet, at one time the Magnolia Library was a hot spot. For example, in 1898, 7,440 books were circulated from the Magnolia Library. In 1926, the Magnolia Library began to offer movies for all to view. Today, only 1,300 books are circulated on a yearly basis and there are no movie showings.

On the other hand, the Magnolia Library Center has been an integral part of the Magnolia community for over a hundred years. It has served as a center for community events, a meeting place for many Magnolia organizations; host to many civic social and educational events; a sporting arena for basketball, volleyball and exercise classes; it was the first responder meeting place in time of community need; and it provided the city with a site to hold voting for local and national elections. It is used as a function hall for parties of all kinds and a place to learn how to train your dog. Of course, it is also a library and yes, it has all the new bestsellers. Tell your friends they can borrow this book from the Magnolia Library.

Magnolia Library Fundraising Events

Magnolia Road Race: The two-mile fun run and five-mile road race was established in 1976 by the Magnolia Library Center volunteers. Usually held in August, the 2008 race will mark the thirty-second anniversary of this well-known race.

Magnolia Art Festival: The art show fundraiser sponsored by the Magnolia Library Center Inc. began in 1977. Awards are given for numerous types of art after a three-day display.

The Magnolia Library Center, 2005.

The artist Sandra Herdman, whose work appears on the cover of this book, has won many awards at this event.

Taste of Magnolia: "This event was originally designed as a wine tasting, and then it developed into something more elaborate," says Peter Lake. This year will mark the thirteenth-annual themed Taste of Magnolia. The February event is planned by the board of directors and is sponsored and hosted by a group of dedicated Magnolia Library supporters. In addition to wine and beer tasting, the event features over a dozen local restaurants presenting their provisions, raffle prizes and silent auctions.

Magnolia Memory Walkway: In the 1980s, resident Fran O'Brien constructed a garden on the side of the Magnolia Library building, in memory of her son. For many years, Fran maintained the garden and kept it beautiful. Upon her death, the garden was dedicated to Fran and a plaque was erected in her name.

For many years other locals assisted with the garden, including, but not limited to, Charles Lycett and Paul Hines. With the passing of these men, money was donated in their names to maintain the garden and construct a brick walkway.

To continue the preservation of the walkway and garden, bricks are sold in memory or appreciation. The bricks that line the walkway are inscribed with names of past and present friends and family of the Magnolia residents. At the writing of this book, there are still spaces available.

Magnolia Historical Society

Magnolia Historical Society Inc. was "founded in 1982 by Frances C. Hines, to collect and preserve the photographs and artifacts of the area." The society began with the

Names of past and present Magnolia residents are inscribed in the bricks that form the Magnolia Memory Walkway. The bricks are sold to raise funds for the Magnolia Library Center.

private collections of curator Fran Hines, James Cook, Lester Strangman, Marion Story Crispin and a few other Magnolia families. The present volunteer board of directors consists of President James Cook, Vice-President Fran Hines and Secretary and Treasurer Hillary Bradley. The present curator is Katie Mazzone.

The Magnolia Historical Society museum has currently outgrown the space it is in. There are approximately two thousand small artifacts in this one-room museum located on the second floor of the Magnolia Library Center. Included among these artifacts are the guest book and many items from the Oceanside Hotel, the entire history of the Millett family, the articles that were found in the Ben Adams Cottage when it was renovated, the articles found in the cornerstone from the Union Chapel, signs from businesses past, postcards, postcards and more postcards, a hat worn by casino-worker Pete Hurley, paintings from renowned artist Frank Knox Morris Rehn (Rehn's studio was the crooked building at the beginning of Magnolia pier, 52 Shore Road) and more.

Women's Club

The Magnolia Women's Club was a home for women and girls away from their homes. The first president of the Women's Club was George Upton, owner of the Oceanside Hotel. The clubhouse was built in 1906 on Shore Road across from the beach. The building, and the fun it provided, survived for almost sixty years until it burned in 1968.

A view down Lobster Lane to Rehn's Studio. *Magnolia Historical Society.*

The Men's Club

The Men's Club was designed by architect James Lee and built in 1909 by wealthy summer residents as a recreational club for their male employees. The *North Shore Breeze* magazine of April 30, 1909, offers a description of the utility of the Men's Club:

> *In the first place, the men employed by the cottages, by the guests at the hotels and by the hotels themselves have no adequate place of amusement. They are not wanted about the Hotels when off duty. They are not wanted loafing in the public square. Yet, where can they go? The hotel management is not anxious to keep them. Quite the contrary. If they felt able to recommend available accommodations for chauffeurs in Magnolia and an excellent restaurant at reasonable prices, it would be a distinct advantage to all concerned.*

The Men's Club hosted pool and billiards, a bowling alley, a dance hall, restaurant, card room and reading room.

As the use of personal servants diminished with time, so did the usefulness of the Men's Club. It eventually was sold and turned into the Riptide Hotel. The operation of the building progressed to Riptide apartments, and is now the Landing apartments.

Buildings at Cole Square

The large building in Cole Square that now houses the Magnolia House of Pizza and Italian Cuisine was first owned by Leon Foster in the late 1880s. The establishment was

The Women's Club was a home away from home for women and girls. *Magnolia Historical Society*.

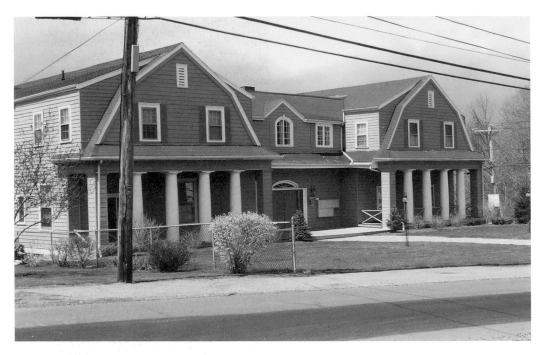

The building that was once the Men's Club is now an apartment building. The bowling alley remains on the lower level, circa 2006. *Magnolia Historical Society*.

then obtained by a Mr. Burnham. Subsequently, the Lycett family obtained the property and moved their post office and grocery store to this establishment from the building across the street (now Magnolia Variety). Later, it was transformed to a drug and grocery store owned by "Doc" Oliver Viera, who purchased it in 1925. "It has long been suspected, that not all spirits sold from Doc Viera's store were for medicinal purposes." Born on October 27, 1897, "Doc" became a noteworthy gentleman, as he was the "life of city elections for 20 years," serving as a city counselor in 1967. Doc fought to keep the Blynman School open, was a factor in obtaining Knowlton Park for the city, secured the Magnolia telephone exchange and was also a proponent in the construction of West Parish School.

After Doc's death, Barry and Gloria Harvey purchased the building from Doc's granddaughter, Maureen McCarthy, in 1975. The Harvey family thankfully preserved the onyx counters, the "physician's office" that now encompasses the bathroom and many of the other antique fixtures that made up Doc Viera's pharmacy.

The business then boasted an oyster bar. Mr. Harvey later rented the outfit to a family who changed it into an ice cream parlor. After the failure of each of these businesses, the storefront was rented by Sal Ventimiglia in 1987 as the Magnolia House of Pizza. After ten years in business, Sal sold the business to Tony DiMercurio. After ten years of renting the space for his business, Tony purchased the building on December 28, 2007. The space next to the restaurant that was previously the post office was recently an office for a real estate agent, but remains unoccupied at the writing of this book. This establishment has been used for business for 145 years, as of this writing.

Oliver "Doc" Viera owned the drugstore in the square. "It has long been suspected that not all spirits sold from Doc's were for medicinal purposes." *Magnolia Historical Society.*

The property that is now the Magnolia Variety Store was first owned by the Lycett family and featured a grocery store, drugstore and post office all in one. Later, when the post office was moved across the street, Brigham's meat market did business at this corner location. Albert West, along with other locals, raised chickens and meat for sale at this market.

Louis Gradwhol then purchased the estate and moved his grocery store from the building that was recently the address of the Magnolia Beverage Store and the Edgewater Café on Raymond Street (formally the A&P grocery) to the new corner market. After selling the business to another local family, the Magnolia Superette burned in 1976. Louis Gradwhol sold the assets and property to Cumberland Farms, a franchise, which ran the store until it was purchased by Judge Jedrey. In 1980, Jedrey decided to leave the area and sold the property to Charles "Chuck" Azarian, who now owns and manages the Magnolia Variety Store. Ironically, the people who managed the Magnolia Superette at the time it burned also once owned the same house that Chuck Azarian and his family now occupy.

The beginning of Magnolia Avenue has a stretch of buildings that now include a dentist's office, an acupuncturist, a craniosacral therapist and a small apartment. Throughout the years, this building has been used as Hunt's Meat Market, Johnson's Plumbing, the Magnolia restaurant, the Packet restaurant and Archie's restaurant to name a few.

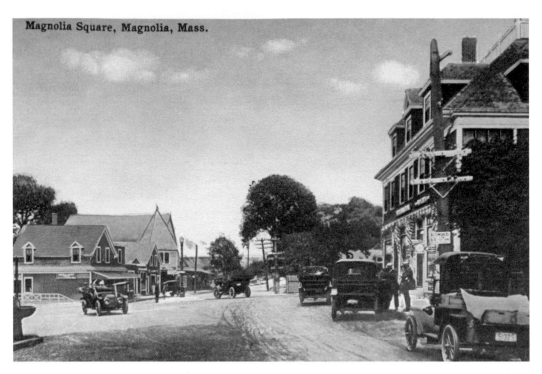

Magnolia Square, Magnolia, Mass.

A view of Magnolia Square from Fuller Street toward Magnolia Avenue in the early 1900s. *Magnolia Historical Society.*

A view of Magnolia Square from Fuller Street toward Magnolia Avenue in 2005.

Hunt's Meat Market went out of business. The Packet restaurant, established in the 1940s, was owned by Mary West, mother of the founder of the Magnolia Historical Society, Frances Hines, who, as a young girl, was one of the waitresses at the Packet. The Packet was the place to go for breakfast and lunch. "People would be lined up all the way to Davis's garage to eat at the Packet."

In the late 1940s, the restaurant changed hands and was sold to Archie Dort. The eating place was then renamed "Archie's." Archie's was famous for Mrs. Dort's home-made donuts and crullers, best enjoyed with a great cup of coffee. It wasn't until the mid-1980s that the building was renovated and used for medicinal and residential purposes.

Davis Stables and Livery housed the horses used for transportation of hotel guests, but when the livelihood of hotels and horse-drawn carriages diminished, so did Davis Stables. Davis then established "Davis Garage," an auto-repair shop. The Davis building was dismantled, and Bill McCarthy purchased the property and built the cement structure that stands today. Bill operated a gas station at the site for some time, and later sold to Wilbur Johnson. The well-known Bob McDonald soon after purchased the Magnolia Service Station, which remained the only gas station in Magnolia until the 1980s, when the price of replacing the tanks forced Bob to discontinue providing gas. After continuing auto mechanics for many years, Bob retired at the end of 2005 and sold Magnolia Service Station to Samir Makhlouta in February 2006.

A notable man, Mr. Harold Vaughn, born in Liverpool, England, came to Magnolia in the early 1900s. He was a steam engineer associated with the White Star Line. Upon his arrival in this country, Mr. Vaughn worked mainly in the hotels in Boston. He soon landed a job with the electric company in Gloucester. With that, he moved to an apartment above Davis Stables on Magnolia Avenue. Mr. Vaughn later moved to the

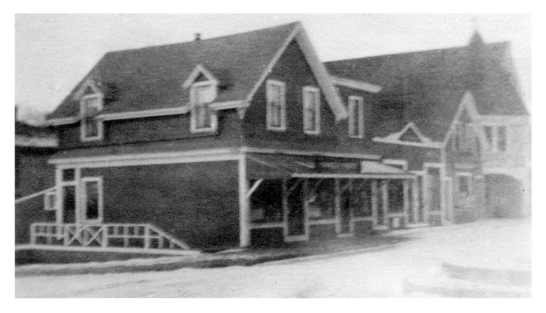

Hunt's Meat Market on the corner of Magnolia Square. *Magnolia Historical Society.*

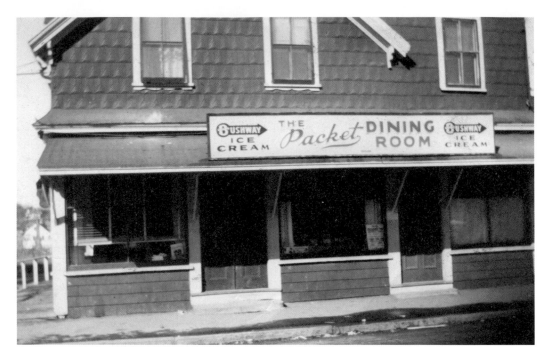

The Packet restaurant was extremely popular. "People would be lined up all the way to Davis Garage to eat at The Packet," circa 1940s. *Magnolia Historical Society.*

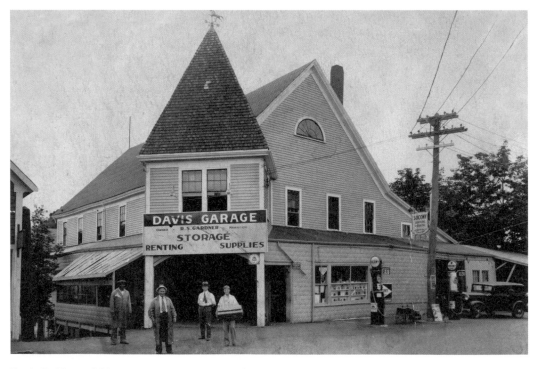

Davis Stables and Livery housed the horses used for the transportation of hotel guests. With the invention of the automobile it became Davis Garage. *Magnolia Historical Society.*

bungalow at 25 Ocean Avenue, owned by Loring Cook. A sign was nailed to the outside wall: "Never Inn." When Vaughn retired from the business in the early 1960s, he had a new sign made: "Always Inn."

"Magnolia Square"

Cole Square was officially named after the first man from Gloucester to be killed in World War II. In 1945, Magnolia dedicated an honor roll of seventy-seven names of servicemen and -women in Magnolia Square on the Green. Unfortunately, this honor roll was first damaged and was later "seen being put in the trunk of a Caddy" and never returned.

The square is the official hangout and meeting place for the coming of age, and always has been.

The central part of Magnolia has lent its popularity to many generations. This is the place where young people were able to meet children a few years younger, as well as the older square generations. Although usually discouraged by parents, this area drew the Magnolia kids to establish the relationships that have endured through the years. We were there. Our parents were there. Their parents were there. Their parents were there too.

Judy Gilliss, who still stops to talk to everyone she knows from the square, has continued the memories of her generation with her stories from the past and colossal

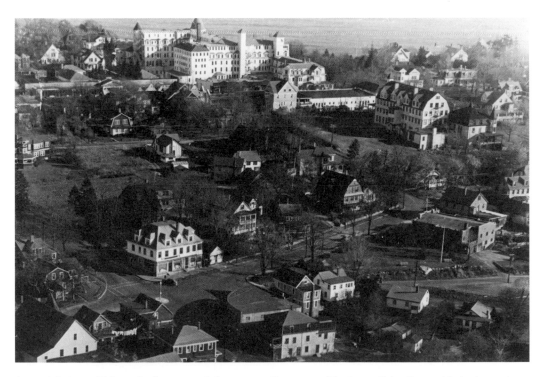

An aerial view of Magnolia Square and the surrounding area, with views of the Oceanside in the background. *Magnolia Historical Society.*

amount of information she knows about the history of Magnolia. She has hosted a reunion of friends and family to collect memories and smiles. Dubbed "the Square Gang," Judy hosts an informal meeting of the gang at random. Their last meeting was in 2003 at the Magnolia Library Center to have "a night at the square."

As a matter of fact, just last summer, as I was going to the Magnolia Variety Store, I saw Mr. Bill Rose, Mr. John Latassa and Mr. John Geary leaning against the wall at the variety store, talking. They weren't aware that I was writing this book, so I commented, "Still hanging out at the square, huh guys?" Mr. Rose replied, "Always will."

This is the place where you will see the many faces of Magnolia, old and new. Those who have moved out of town and come back for the holidays are always at the square at some time or another, because, of course, the Magnolia Variety Store is the one and only stop for groceries, movies, alcohol, the card you forgot to buy for that special occasion or anything else you might need.

I walked my own sons though the square the other day and thought about what it might be like when they are old enough to "hang out at the square."

Hammond Castle

John Hays Hammond Jr. was born in 1888 in San Francisco, California. His fascination with castles flourished when he moved to England in 1898. John Dandola, in his book *Living in the Past, Looking to the Future*, wrote:

> *John Hays Hammond, Jr. was a preeminent inventor in the field of radio control. A protégé of Thomas Edison and Alexander Graham Bell, he filed 800 patents on more than 400 inventions, laying the groundwork for target seeking torpedoes and guided missiles, TV remote control and cell phone technology.*

Mr. Hammond established the Hammond Radio Reese Corporation in 1911.

> *In 1912, he served as United States delegate to the International Radio-Telegraphic Conference in London, and in 1927 he was appointed by President Calvin Coolidge to represent the United States at the International Radio Conference in Washington D.C.*
>
> *He conducted some of the earliest experiments in frequency modulation broadcasting, invented single dial tuning for radio, filed a patent for telephone amplification (purchased by the Bell Telephone Company for use on its long distance lines) and made several contributions to the development of the modern radio tube.*

In the early 1920s, Hammond was summoned by the Italian dictator Benito Mussolini to assist with a secret communication system.

> *Hammond was impressed by the rapidity of the availability of parts and equipment Mussolini offered, but Hammond soon refused to work for Mussolini when he discovered*

his efforts were to be used against anti-Fascists, some of whom were close friends to Hammond.

John Hammond also developed a radio-controlled torpedo for the navy. During his research, Hammond did radio control experiments in Gloucester Harbor. In 1914, he sent a forty-four-foot pilotless ship on a 120-mile round trip. This activity attracted the U.S. military, which thought it was being attacked.

Hammond was also very interested in music. One of his inventions in the field included the "dynamic amplifier," known as a stereo system today. He was able to develop this innovation with the help of friends Serge Koussevitsky, Igor Stravinsky and Leopold Stokowski. He conducted experiments with his amplifier by having "radio wars" with a gentleman across the water living in East Gloucester. Each would work to play their music louder than the other.

Some of the other developments Hammond presented were: "synchronization of motion pictures, radio dynamic controls, television communications, a variable pitch propeller and cosmic ray detector…The profits from his inventions allowed Hammond to build a castle in Gloucester overlooking Gloucester Harbor."

Hammond wrote a letter to his father in July 1924 that stated:

In a few years after I'm gone, all my scientific creations will be old fashioned and forgotten…I want to build something in hard stone and engrave on it for posterity a name of which I am justly proud.

Hammond started building his castle in Magnolia in 1926 as a wedding present for Irene Fenton.

The castle, called "Abbadia Mare" and overlooking Norman's Woe in Magnolia, was completed in 1929. The castle has a collection of medieval art and artifacts, including a moat, drawbridge and many portions of various European buildings that were shipped to Hammond.

The Great Hall is 100 feet long, 25 feet wide and 58 feet high. It has an 85-foot tower that was designed to encompass the 10,000-pipe organ, built by Hammond himself. The organ has been engulfed with parts from different organs from around the world. To this day, the Hammond organ is among the most magnificent and unique in the world.

The courtyard, located in the middle of the castle, has a large Roman pool in the middle, surrounded by pieces of storefronts brought from around the world. The pool water is kept blue in color by a remaining secret invention of Hammond. Tropical foliage that surrounds the pool is kept lush by way of artificial rainstorms fabricated by yet another of Hammond's inventions. He worked on his inventions in the castle laboratory. A tour of the Hammond Museum will show you this lab.

Hammond Museum was incorporated in 1930, and in that same year Hammond and his wife moved into the castle. (Irene was an artist. She died in December 1959.) Hammond lived in the castle with his servants, an English butler and several generations of Siamese cats until his death.

John Hayes Hammond died on February 12, 1965. In his will, he bequeathed the Hammond Museum and all of its contents to the Catholic Archdiocese of Boston. Mr. Hammond is buried beside his castle home in a tomb that overlooks the water.

Magnolia Fire Station

The first type of firefighting equipment used was termed a *handtub*. It had a hand-drawn and hand-operated engine. Steam-operated engines later replaced the handtubs. The first two horse-drawn steamers used for Gloucester firefighting were purchased in 1864. That year, Magnolia Steamer No. 1 was located in a two-bay engine house on School Street in Gloucester.

In order to get water back then, the city had underground reservoirs of water called cisterns. They were made of brick, in the shape of a bowl, and were about fifty feet across the top. They were usually placed at street corners. Water was pumped either manually or by steam engine out of the cistern and onto the fire.

In 1885, the first Magnolia fire engine house was built on Magnolia Avenue, in proximity to what is now Magnolia Service Station. Magnolia was becoming an exclusive summer resort and numerous mansions were being built on the point—it was clear that Magnolia needed a fire station.

In 1903, the fire chief declared that he wanted even better fire protection due to the influx of people during the summer. A wood structure was then built on Fuller Street in 1931, replacing an earlier wood fire station.

Everett Butler was the first foreman, and James May was the first engineer of the Magnolia stations. A 1942 Dodge truck with the trailer converted from a horse-drawn ladder truck was used in Magnolia under the name Ladder No. 3 until 1953.

Magnolia Fire Station was closed in June of 2004. At this time, due to financial constraints, the Magnolia Fire Station is open randomly.

Fire Curse

Revealing the Magnolia fire curse, almost every hotel in Magnolia, the largest apartment building in the area and the length of Lexington Avenue have all burned to the ground, twice. All of these fires were less than a quarter mile from the fire station.

Oceanside Hotel: It had its first fire in 1927. It burned to the ground on December 11, 1958.

Oceanside Restaurant: Located at 28 Fuller Street, next to the fire station, it burned on June 17, 1978.

Blynman Hotel: Burned in 1892.

New Magnolia Hotel: Located on the corner of Lexington Avenue and Flume Road, the first time this lot burned was in 1908.

Green Gables: Located on Fuller Street and Hesperus Avenue, a stone's throw from the fire station, this twenty-five-room boardinghouse for single ladies was leveled by fire at 1:16 a.m. sometime in the 1960s.

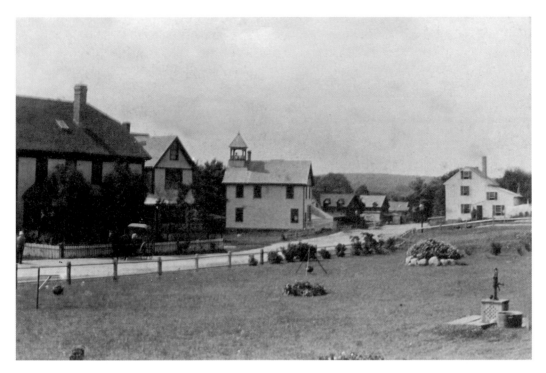

The fire station, complete with a bell, was a wood structure located on Fuller Street. Note the house in what is now Knowlton Park. *Magnolia Historical Society*.

The present brick Magnolia Fire Station replaced the wood structure in 1931.

Town Garage: Located at 26 Magnolia Avenue, the garage was gutted by fire due to faulty wiring. According to the *Gloucester Daily Times*, the "2 alarm fire gutted the 2 ½ story wood framed Magnolia Garage and took with it 3 automobiles, an oil truck and a supply of tires." Of the automobiles, two Chryslers and a Dodge belonging to Loring Cook, who used them as taxis, were among the ruins. Owners at that time were Stephen Kraczynski of Wenham and Edward V. Davis of Lexington Avenue in Magnolia; they had purchased it in 1946. A broken fire hydrant was blamed for the total loss.

Women's Club: Located on Shore Road, this building burned in 1968. It has been said that the fire engine would not start, so the men "rolled it down the hill" to the fire.

Magnolia Superette: The Magnolia Superette burned in the year 1976. This space is now owned and operated by Charles "Chuck" Azarian as the Magnolia Variety Store.

Lexington Avenue Colonnade: This fire began about 10:30 p.m. on December 23, 1991, in the basement of the Oyster Shell, a used clothing store located in the middle of the Colonnade. The fire quickly advanced to a five-alarm fire that engulfed the Magnolia House of Pizza, Jennifer's Perfect Setting, J.D. and Myers Pub, Dee's Chicken, the Oyster Shell, Kate's Kanvas, Jim Berkman's the Last Horse art studio and two vacant storefronts. Ironically, the Magnolia Fire Station had just been closed because there was "no need for a station in Magnolia." This fire destroyed the first mall located within the historical buildings on Lexington Avenue. This is the second time this lot was burned.

Loyd Waites, the owner of J.D. and Myers Best Friends Inc., was the only establishment that held insurance during the fire. A class action suit was filed for all of the business owners who lost their belongings. A lawyer from Boston was able

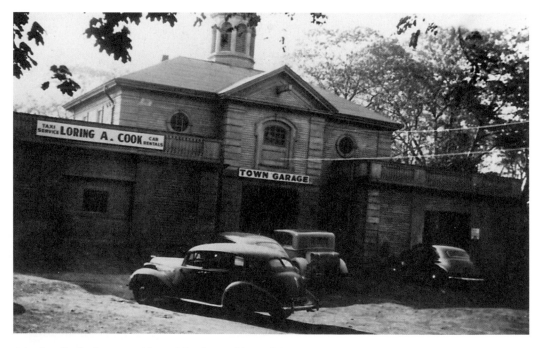

A broken fire hydrant was blamed for the total loss of the Town Garage, circa 1946. *James Cook*.

to acquire a settlement for everyone involved. A video of this fire is available at the Magnolia Historical Society.

Ocean Terrace Condominiums: Located at 2 Ocean Avenue, just behind what was once the Colonnade, a fire broke out on June 1, 2002, and left fifty-seven people homeless. The fire began on the third floor at approximately 11:00 a.m. The cause is still "unknown," but it was believed to be from faulty wiring. This is the third time this lot burned.

The Magnolia Library Center was used as the outpost for the Gloucester Chapter of the American Red Cross and volunteer Magnolia residents to assist victims. With the help of the Red Cross and donations from generous friends and neighbors, each person affected by the fire was able to have the necessities of life at that tragic time.

Post Office

The first mail came to Magnolia by boat or coach. The Magnolia Post Office started operations in 1850, located in a little building across from what we know as the May House near the corner of Western and Magnolia Avenues. The shop comprising the post office and a grocery store was run by Lorenzo B. Story. The first documented letter carrier was Oscar Story in 1908.

Subsequently, the station was moved to the Lycett Building, which is now the Magnolia Variety Store. Mrs. Authur Lycett was the postmistress at that time. After her death in 1910, the position was filled by their son, Fred Lycett. Arthur Lycett purchased the large building in Cole Square where the House of Pizza is today, and moved the post office and his Raymond Street drugstore to that location. Fred Lycett died ten years later in

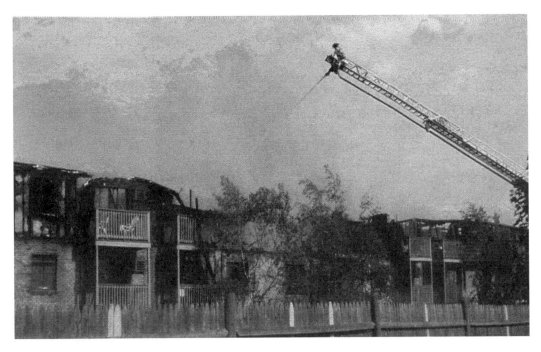

A fire leveled the Ocean Terrace condominium complex at 2 Ocean Avenue on June 1, 2002.

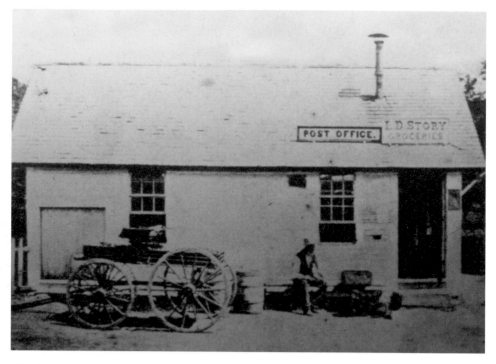

The first post office in Magnolia began operations in 1850. It was located across from the May House on Western Avenue. *Magnolia Historical Society.*

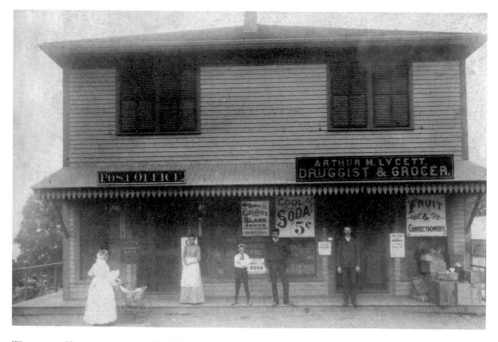

The post office at the Lycett Building on Magnolia Avenue across from Englewood Road. This building is now a private residence that reads "P.S. Lycett" above the door, circa 1920. *Magnolia Historical Society.*

Postman Steve Asaro at the Magnolia Post Office on Lexington Avenue, circa 2005. *Lisa Ramos.*

1920. The position of postmaster was handed down to John Lycett, and with that, the post office was relocated to the P.S. Lycett building on Magnolia Avenue, across from the beginning of Englewood Road. For economical reasons, the Lycett family decided to move their drugstore from the large building in Cole Square to the P.S. Lycett, Magnolia Avenue location in the 1960s, and the postal service was moved to Lexington Avenue, where it stands today.

Magnolia's Churches

The Chapel

Built in 1860, the Chapel was the first nondenominational church erected in Magnolia. It was located across from the Magnolia Cemetery on Magnolia Avenue. At that time, there were no preachers available to serve the Magnolia residents; therefore, Magnolia had circuit preachers who were paid in chickens and grain. The Chapel served not only as a church, but it was also the first location of the American Red Cross.

Union Chapel

On June 19, 1884, Mr. William B. Fuller of Bismarck, Dakota territory, along with Bernard Stanwood, recorded a deed to sell land on the corner of Flume Road and Field Road, to the trustees of the Magnolia Church Association for the sum of $375. The trustees included T. Jefferson Coolidge of Manchester, Mr. James Perkins of Gloucester and Mr. James Freeland of Newton.

In order to raise monies to build the church, ladies of the town formed a committee and held a fair at the Hesperus House to sell "useful and fancy articles." Money was also donated by hundreds of people from every part of the country. The same architect who designed the Magnolia Library, Cummings, stated that the cost of the building would be $850.00. To their surprise, the ladies raised more than enough money to build the chapel, a total of $1,951.73. The Union Chapel was constructed in the shape of a cross, but remained a nondenominational church. The inside walls were shingled, a Cummings signature design. Ministers were hired from several denominations to hold services, and the first library room made its debut here.

In 1924, after forty years of service, the Union Church was closed. The round, stained-glass window that was above the altar and the sizeable bell from the bell tower were moved to the Union Congregational Church on Norman Avenue, where they remain today.

The building stood empty for a number of years until October 30, 1945, when the property was purchased by Mansour Karem from the trustees of the Magnolia Church

Built in 1860, the Chapel was located across from the cemetery on Magnolia Avenue. *Magnolia Historical Society.*

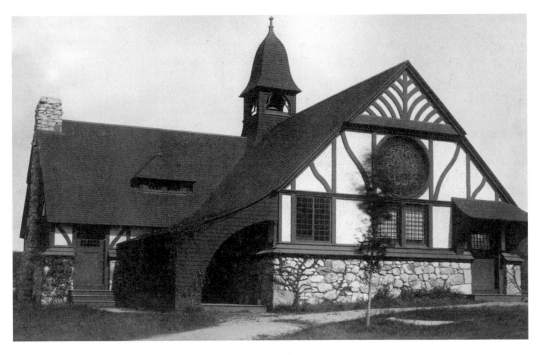

Union Chapel is located on the corner of Flume Road and Field Road. The window and bell tower were moved to the Union Congregational Church. *Magnolia Historical Society.*

Association—J. Gilbert Crispin, Loring A. Cook and Fred R. Dunbar. The church was then transformed into a private home. Rumor has it that he used Salem prison labor to complete the conversion. Apparently, the original owner never lived there. Deed transfers continued through Beatrice Silversmith in 1948 and Eve Gradwohl in 1960. It was then purchased by Barbara Nicastro, owner of Barbara's Beauty Shop in 1961, sold to William Baker in 1964, a year later sold to Paul and Kay McAvoy and then purchased in 1968 by present owners Abdullah and Lynn Khambaty.

A fabulous conversation with Lynn revealed that many of the original details are preserved within the walls of the former Union Chapel: Cummings-style shingles remain in some rooms; the roof has its original skylights (believed to shine light upon the altar); there are a rosewood Knabe piano, a "heavily carved" table, programs from the 1920s and 1930s noting international speakers, a massive brass and milk glass Tiffany-style chandelier and many candlesticks. No additions have been made to the house and it remains in the shape of a cross.

Cornerstone

On Sunday, August 24, 1884, the cornerstone containing a time capsule (a copper box gift from L.E. Smith) "to be opened in 100 years," was laid at the Union Chapel. At 5:00 p.m. that day, the people commenced a program and deposited the box behind the cornerstone.

The box contained a sketch of the history of Magnolia Point, list of subscribers to the church fund, statement of organization, circular of July 1884, circular of fair committee, sketch of the chapel, copy of the Boston Transit *newspaper, and order of exercises at the laying of the corner stone.*

The same time capsule planted in the cornerstone on August 24, 1884, was opened on the hundredth anniversary, on August 25, 1984, with a three-day celebration dubbed Magnolia Heritage Days. Magnolia residents dressed in heritage clothing, celebrated with a Lexington Avenue parade, sang the old hymns noted on the program of 1884 and commenced the day to open the time capsule.

Unfortunately, the hundred-year-old copper box was not sealed well and many of the items inside were too fragile to remove. This box and contents can be viewed at the Magnolia Historical Society.

On that same day, the villagers planted a new time capsule, this time a stainless steel, vacuum-sealed box engineered and donated by Paul Fiahlo. The box was sealed with the program of Heritage Days events, an item from every club in Magnolia, a Magnolia Road Race T-shirt, numerous pictures taken by Joy of Photography owner Len Wickens, the written history of many Magnolia residents, a PROM (programmable read-only memory), along with a schematic as to how to read it (as we are sure technology will certainly change in the next hundred years), and a tape recording of the celebration. The newest time capsule is destined "to be opened in 100 years" in August 2084.

Union Congregational Church

The Union Congregational Church, designed by Cummings, formed in 1887. The craftsman-style church was not officially completed until 1899, although it was officially opened in 1893. It presents with the signature shingled walls of Cummings.

In 1924, it received the round, stained-glass window and the bell salvaged from the closed Union Chapel. Recently renovated to its current beauty, the church is and has been well known for "VBS," Vacation Bible School.

Saint Joseph's Chapel

The Magnolia Library was the first to host Catholic services for church—ironically the first place to offer a library was at a church. There were very few year-round families who were Catholic at the time, the majority being those who came in the summer to work in the homes of the wealthy summer residents. "Sunday best" was the attire for these "meetings" and they rode their horse-drawn wagons to the gatherings. Fees for services were five dollars per year per family to attend. Employers had to pay the fee for their "papist" servants.

With the influx of immigrants, the library hall became too crowded and a group was organized to apply for a chapel to be built in Magnolia. Saint Joseph's Chapel (1911) was the first church to offer Catholic services to residents and visitors.

Before Saint Joseph's Chapel was built, the property was used as a camping ground for Native Americans who came from Old Town, Maine, during the summer. The Native Americans made baskets and wares to sell to the summer visitors of Magnolia. John Stanwood sold the property to the Roman Catholic archbishop of Boston for "one dollar and other good and valuable considerations" on October 18, 1910.

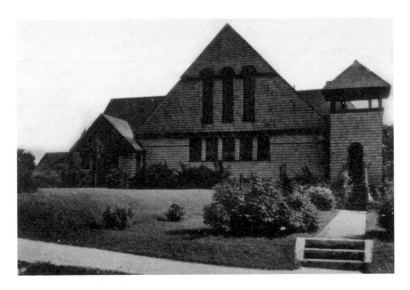

Union Congregational Church in the early 1900s. *Magnolia Historical Society*.

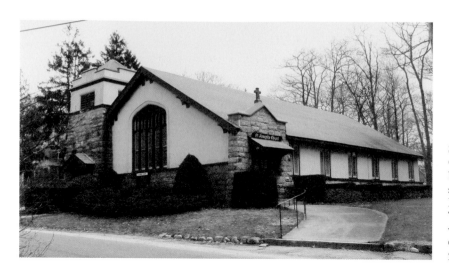

Saint Joseph's Chapel was built in 1911 by stonemasons the Ballou brothers. The last Mass was held on Christmas Eve 2004, circa 2005.

Saint Joseph's Chapel was built by Ballou Brother stonemasons. The Ballou brothers asked the local neighbors to donate stone to build the church. Ed Ballou lived in the house at 44 Englewood Road that once belonged to John and Miriam Carter and is now owned by Magnolia native James Mondello. Dennis Ballou resided at "Casa de Codinha" at 29 Ocean Avenue. They were able to complete the building with the donated stone, and Martin "Cappy" Burke laid the cornerstone in 1911.

The girls who worked for the wealthy raised the money to purchase the Stations of the Cross. The original pews were made of mahogany with numbers on each. The first marriage performed at Saint Joseph's Chapel occurred soon after the church opened. The bride was Catherine Martin and the groom was John Chane. Masses were conducted only in the summer until 1926. Louise Viera played organ for the choir at Saint Joseph's in the 1930s and 1940s.

Bishop Desmond owned a cottage in back of the church. During World War II, when Father Daniel Sullivan was on leave from the navy, he would stay at his Uncle Desmond's cottage and would occasionally say Mass at Saint Joe's. Father Sullivan later became a monsignor.

The summer fairs brought the people of Magnolia together as one big family working toward a common cause. We could always count on a neighbor to chair the activities of the Saint Joseph's Church Fair. In 1988, the chairs were as follows:

Baked goods: Celine Toye
Beverages: Joe Heanue
Books: Alfreda O'Hara
Coffee and Donuts: Betty Edmonds and Diane Colby
Children's Table: Marie Lacey
Handicrafts: Liz Edmonds
Jewelry: Ann McCarthy
Supper and Publicity: Fran Hines

Ticket Booth: Betty Murphy
White Elephants: Fran Dussord, Fran Bradley and Priscilla Zager
Chuck Wagon: Charlie Toye

You could always "get a free roll with every hot dog" at the chuck wagon. People lined up for Millie McCarthy's chicken, the Lions Club fish fry or to buy raffle tickets for the cut and blow dry. (What did that priest say? Ask a Magnolia resident, they'll tell you.)

Saint Joseph's Chapel has been financed with community love for ninety-seven years. The first caretaker of the church was Pat Hyland, an Irishman who resided on Englewood Road. Mr. Hyland retired at age seventy-five and turned the job over to Albert West. Mr. West landscaped the churchyards until he was unable, and then his sons took over. They later passed it to John Edmonds. John continued landscaping and maintenance until the church closed in 2004. In 1986, Saint Joseph's Chapel received an award from the Gloucester Civic and Garden Club for having the best landscaped churchyard in the city of Gloucester.

Sunday school classes were first conducted by nuns from Saint Ann's and later progressed to volunteers from the community.

Mary West, Alfreda O'Hara, Fran Hines and Helen Muise were among the many ladies associated with the guild who volunteered cleaning services for the church. Past presidents of the Saint Joseph's Guild include Elizabeth Dunbar, wife of Harold; Florence Griffen, wife of Burton; Margaret Bachmann, wife of Emil; Mary West, wife of Albert; Louise Viera, wife of Oliver "Doc"; and Ruth Cook, wife of Peter. The objective of the guild was to "bring women together in a closer bond of friendship" and to "obtain money to be used for articles needed in the sanctuary of the church"— "initiation fee shall be one dollar per year."

Gerry and Bonnie O'Neil were regulars in reading scripture and passing Holy Communion, and Joe Trupiano served the church as cantor. Organist George Monbourquette added much to the services at Saint Joseph's Chapel. George could most often be seen at the rear of the church playing the organ and organizing the parishioners in hymns. After many years of residence on Treetop Lane, off of Village Road (formally Dalton Avenue, but changed when the 911 system was being installed in Magnolia), George now lives at an assisted living complex in Ipswich and continues to play the organ for the residents on a weekly basis. George should be commended for his ability to always create happiness. The good Lord blessed him with his talents and he blessed the residents of Magnolia with his gift.

Many of you reading this book will have celebrated a Mass at Saint Joseph's Chapel, or maybe you attended a wedding, a baptism, a first Holy Communion or even a funeral there. The church, always filled with familiar Magnolia faces, celebrated its final service on Christmas Eve 2004. It was closed forever on Christmas Day as a result of the recent scandal.

After just over four years of emptiness, the archdiocese has decided that the church built by the Ballou brothers and loved by the community would produce a buyer if the building were gone.

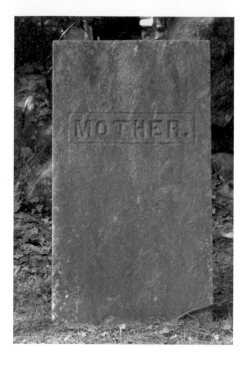

A gravestone in Magnolia Cemetery inscribed "Mother." Some believe she was an owner of the haunted Story House. To this day nobody really knows whose mother she was.

As of the writing of this book—and I mean right now, Wednesday, January 16, 2008, at 7:00 a.m.—crews are preparing for the demolition of Saint Joseph's Chapel on Ocean Avenue in Magnolia. I went last night to say my final goodbye to the church that served this neighborhood for ninety-seven years.

The church's last day was January 22, 2008. The archdiocese donated some of the smaller pews to Magnolia residents on a first come first serve basis. The last remaining stained-glass window was removed from the granite tower via an excavator, and has been lent to the Magnolia Historical Society. The cornerstone from Saint Joseph's Chapel has been donated to the Magnolia Historical Society.

Magnolia Cemetery

In 1881, land was purchased from Daniel Butler in order to enlarge the existing Magnolia Cemetery. Among those buried there are Ben Adams; most of the May family, including Jonathan; Daniel Fuller; most of the Knowlton family; the Millett family; Solomon Burnham; Arthur Lycett; Henry West; Lenny Carlson; Thomas Knight; Jonathan Gilbert; and Alan Seaburg, author of *At the Fair: The Boston Immigrant Experience*.

Magnolia Cemetery has an unidentified stone marked with only the word "Mother." An old tale states that the grave belongs to the wife of the family that swindled Gilbert into exchanging his house on the north side of Western Avenue for a house in New Hampshire. Yet another fable states that the grave belongs to the woman who once owned the haunted Story House. To this day, nobody knows whose "Mother" she was.

Restaurants, Nightclubs and Dancing

North Shore Grille Club/Del Monte's

The building at 2 Lexington Avenue was constructed by a woman named R.H. Sterns between the years of 1890 and 1910 as a private home and clothing store.

The North Shore Grille Club was established on June 10, 1911, at this location. The club was mainly for the gentlemen of the area, but in order to please the women, it was open for tea from 4:00 p.m. to 6:00 p.m. in the back rose gardens. The evening hours followed, with orchestral music and dancing.

In 1916, the owner, Maude Wilt, had liabilities of $10,384.23 and no assets to cover them. She eventually went bankrupt.

The future held many positions for this locality, as you will see later in this book. After the demise of the North Shore Grille Club, the name was changed to Del Monte's. The new owner, Frank Fishbourne, then took Del Monte's and moved the business to a location down a road near what is now Ocean Highlands. He took his casino business from the Oceanside Hotel and renamed his new enterprise near Rafe's Chasm, "The Casino."

The Casino

The Casino was the ultimate summer nightclub—ultra swank, with ultra swank customers and ultra swank prices. It was later purchased by Ruby Newman and Sammy Eisen. The Casino hosted many celebrities after their appearance at the North Shore Music Theatre, including Lucille Ball, Frances Langford and the Red Sox shortstop Vern "Junior" Stephens. The Casino also hosted one of the early Miss Massachusetts pageants.

The ultra swank casino was robbed on July 15, 1940. Two masked men entered the casino to find seventeen sleeping employees. The workers were bound, gagged and forced at gunpoint to reveal the location of the night's receipts. The thieves escaped in a convertible coupe Packard and headed toward the dirt roads of Essex. The police chief of Manchester drove in "hot pursuit" to entrap the burglars, but had to back off his black Dodge sedan when the thieves opened fire with a submachine gun. Luckily,

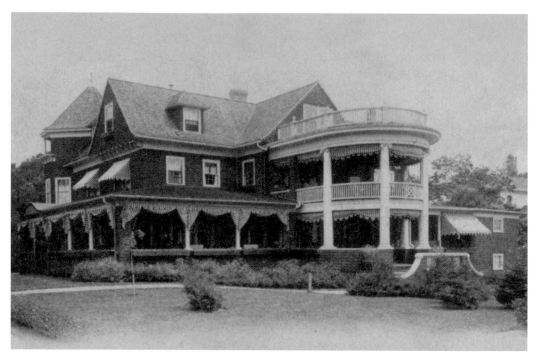

The "teahouse" at 2 Lexington Avenue. *Magnolia Historical Society.*

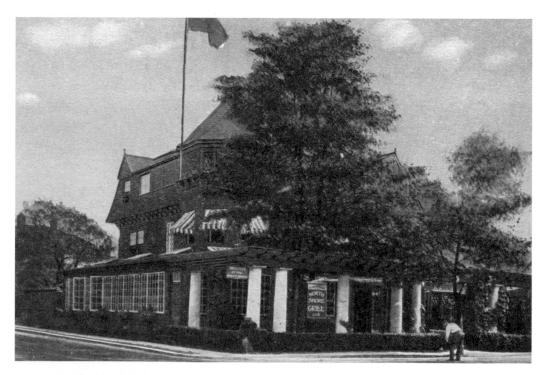

The North Shore Grille Club, 1911, was a gentlemen's club at 2 Lexington Avenue. Women were served tea in the gardens behind the building. *Magnolia Historical Society.*

Sammy Eisen and Ruby Newman owned the "ultra swank" Casino nightclub near Ocean Highlands. Lucille Ball, Frances Langford, Vern "Junior" Stephens and the Miss America pageant all presented there. *Magnolia Historical Society*.

nobody was hurt. The Packard raced out of sight and was later found abandoned near Lowell. Not even a month later, the *Gloucester Daily Times* reported another bank robbery that delivered the suspects of the Casino robbery to a jail in Concord, New Hampshire. They were released that same month.

In 1954, the Casino was devastated by fire when the crew who was raking leaves was out to lunch at Archie's restaurant. In March 1959, the same gentleman who purchased the Oceanside lots also purchased the Casino lots. Herbert Kaiser's plan was to build "33 estate lots about 40–60 thousand square feet each—8 with oceanfront lots." This is the area we now know as Ocean Highlands.

The Surf Restaurant

Originally part of Davis Garage, the land was purchased by a Mr. Karem and Mr. Salah who established The Red Barn restaurant. In 1956, the restaurant was purchased by Mr. and Mrs. Albert Lazisky and renamed the Surf Restaurant. The thriving restaurant became extremely popular in the late 1960s and early 1970s. Many famous faces were seen dining at the Surf, including Liza Minnelli and Walter Brennan to name a few. Owners included Chris Sabanty, who purchased the Surf for his sons Charlie and Cary to run, and Bob Morello. In the early '80s a car drove through the side entrance to the Surf, which was not a "drive-through" restaurant.

After numerous dinners served, years of employment and pleasure for the Magnolia residents, the all-in-one banquet, wedding, meeting place and local bar closed its doors in the 1990s for renovation. The new owners closed the banquet hall and named the restaurant Toaramina's. The eatery survived only a short length of time.

The restaurant located partly in Manchester and partly in Gloucester closed on July 1, 2001, after forty-three years of business. Paul Fiahlo states, "When the Surf went, everything went with it." The building was then demolished. A developer wanted to purchase the land and build an assisted living facility on the site. After some debate over land ownership, the City of Gloucester and the Town of Manchester-by-the-Sea, along with a generous million-dollar donator, raised $2.4 million to purchase the land. It was dedicated as Surf Park in 2002.

The Patio

Mr. and Mrs. Gabriel Hakim, also Egyptian art retailers, originally fashioned this section of Lexington Avenue as an exotic "bamboo lounge" with live music. The portion on the Steans Estate was later purchased by Harry Samsonis, and then resold to the Surf owner Mr. Laziski.

The Patio restaurant was again put on the market in 1978 and procured by John and Irene Burke on February 1. Irene began her restaurant career as a server at Sterling's lunch counter in Gloucester. She later worked as a waitress at the Patio for

The Surf Restaurant was demolished on July 1, 2001. *Magnolia Historical Society*.

Surf Park was dedicated in 2002.

Hakim, Samsonis and Lazisky. The Burke family has operated the Patio restaurant for thirty years.

Until recently, Irene was well known for her beehive hairdo. Her hair is modern today, but you can still count on the Jolly Roger being on the menu.

Magnolia House of Pizza

The Magnolia House of Pizza was originally established on the Colonnade side of Lexington Avenue, first door on your left after the alley. The Magnolia Pub was situated in the back with saloon-type swinging doors marking the entranceway. Sal Ventimiglia owned the sub shop/pizzeria in the early 1980s and soon moved his business to the space a few doors down, next to the Breakfast Nook. Although he escaped the fire damage in 1991, he did have an oven fire that torched the inside of the establishment. Sal then moved the business to the large building at 35 Fuller Street, in Cole Square, that once housed Doc Viera's pharmacy. Mr. Ventimiglia sold the business to Tony DiMercurio, who celebrates over twenty years in business this year as the Magnolia House of Pizza and Italian Cuisine.

The Local Drinking Hole

Magnolia is still holding the oldest liquor license in Massachusetts. The license was first obtained by Tid Prouse with the business that started as Tid Prouse's Neighborhood Bar.

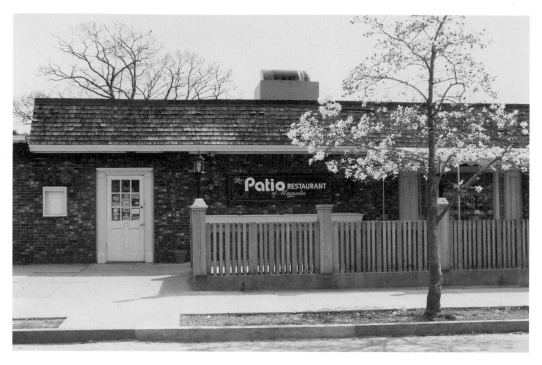

The Patio restaurant was once a "bamboo lounge," circa 2005.

Later changed to the House of Prouse, it was located at 28 Fuller Street, next to the fire department. Tid sold the business and license to Richie and Robbie Amero in the 1940s, when they founded the Cedarwood Nightclub. The nightclub was known for its class, good food, good drinks and top-caliber entertainment.

Since that time the enterprise has had many owners and has changed names numerous times. While the business remained at 28 Fuller Street, the various names were: Todiscio's, John Cain's Steak House, the Open Door, Kettle Cove Restaurant, Stefan's of Magnolia, Poor Richard's of Magnolia, Grey Finch Restaurant and the Oceanside Restaurant. The Oceanside Restaurant burned on June 17, 1978. The building has since been remodeled into a private home.

It wasn't until 1983, when Eric Hartzell (who always had his white parrot on his shoulder), Charles Azarian and his son, Charles "Chuck" Azarian, purchased the license and moved the bar to the former location of A Spot of Tea on Lexington Avenue. Using the same original liquor license, they launched the Magnolia Pub. In 1984, the Azarian family sold their interest in the Magnolia Pub to co-owner Eric Hartzell. Two years later, Hartzell sold the small business to a Gloucester man named Dana Muise. Muise continued to use the name, but poor business habits forced him to sell after only two years. Loyd Waites and Robert Cucurull purchased the business from Dana Muise in 1988. They changed the name to J.D. and Myers Best Friends Inc., although locals still call it the Pub. Mr. Cucurull and Mr. Waites parted ways after only six months in business. Mr. Waites bought out Cucurull, confirming sole ownership of J.D. and Myers Best Friends Inc.

The original location, inside the Colonnade, burned to the ground along with many other establishments on the night of December 22, 1991. Mr. Waites stated that he received a phone call from bartender Frank Miles reporting that there was smoke coming from the Oyster Shell used-clothing store. Mr. Waites stated he believed it was only minor, but when all was over, "the fire was so hot, the slate on the pool table melted."

Many locals were devastated at the loss of the local hangout. All that was left of the Pub was the large hole that had been the cellar. Longing to stay in town, many locals would "party at the local drinking hole."

Loyd Waites tried to find another location for his bar. Meanwhile he tended bar in Essex and continued his psychology practice in Boston. Unable to find another location and anxious about the two-year time limit on his license, he approached the owners of the land and "hole." Sandra and Glenn Marston from Manchester sold the land at 22–40 Lexington Avenue to Loyd Waites for $165,000 in October 1993. Due to limitations, Loyd needed to rebuild and open his business in six weeks, or lose the infamous original license.

On December 23, 1993, exactly two years after the downfall of the first location, and six weeks after the purchase of the land, Mr. Waites was open for business. Upon the bar sit a billiard ball and a bottle of wine, all that is left of the pub of the past, except of course the memories and the shot glass and beer mug I found in the rubble. (You can view these at the Magnolia Historical Society.)

Much unlike the antiquity of the prior site, the new location fills the corner of Lexington Avenue and Flume Road with a commercial-type building that holds no beauty compared with the New Magnolia Hotel that once stood in its shadow.

The new building encompasses a restaurant on the left side and the bar on the right. The restaurant was first run by Ki Moody, who was a well-known waitress at the Breakfast Nook. Ki had a pub-style menu and served patrons in both the restaurant and the bar. The restaurant was later rented by Joe Scola, who called his business Joe Fresca. Strike three came when the

Loyd and Meredith Waites discuss the fire that destroyed the remaining historical grandeur of Lexington Avenue on December 23, 1991.

restaurant was rented by Jay King and Jessica Jameson Lake, as Pastaria Restaurante. For some time after that, J.D. and Myers made its own food. In October 2004, a home run was hit when Dennis Moustakis reopened the Edgewater Café within the building.

J.D. and Myers Best Friends Inc. is well known amongst Magnolia residents as a place "where everybody knows your name," or at least John Ramos does. "We have had many come and go," stated Loyd. "We have had some meet here and get married, like Linda and Dan 'Weasel,' some who were regulars who have now passed on and those who sit in the same spot every time they come here." George Colletti was a regular at this pub; after his death, his dungaree vest was bestowed to J.D. and Myers, where it remains suspended above his favorite seat.

Lexington Avenue Shopping

Nicknamed "Robber's Row," Lexington Avenue once housed storefronts comparable to Saks Fifth Avenue. Ladies wearing long-sleeved dresses, with fancy matching hats, enjoyed tea amid the gardens after a day of shopping before returning to home or hotel. Chauffer-driven carriages and limousine cars filled the streets to take the ladies back to their summer residences.

The building that stands at 2 Lexington Avenue was built by R.H. Stearns at the turn of the century. According to a map of 1919, Ms. Stearns, formally a laundress, soon owned all of the land across Lexington Avenue from the library all the way down the Colonnade, extending down the entire length of Ocean Avenue before it crossed Norman Avenue. Her plan for 2 Lexington was to sell clothing in the lower level and reside above it.

Maude Wilt initiated the gentlemen's alliance, the North Shore Grille Club. Maude soon found herself bankrupt. Just after the place was turned into North Shore Restaurant, a man named Frank Fishbourne purchased it and renamed it Del Monte's. The name soon moved

J.D. and Myers Best Friends Inc. on the site of what was once the majestic New Magnolia Hotel, circa 2005.

with him to the future casino. Mr. and Mrs. Gabriel Hakim established their Egyptian treasure store at that location. As they got older, they decided to move their store location a few doors down to a smaller storefront. When Gabriel passed away, Mrs. Hakim closed the business. The "HAKIM" sign can be viewed at the Magnolia Historical Society.

After purchasing the charred lot of the New Magnolia Hotel from Frank Sprague in 1912, Annie Ryan built "the Colonnade," the first mall. She rented prestigious storefronts to Tiffany's, Jordan Marsh and FAO Schwartz. She planted fabulous rose gardens in the back, where ladies would sip tea.

The enterprise was sold to Blair Villa in the 1960s at Annie's retirement. Blair later sold the lot to Sandy and Glenn Marston. After the fire in 1991, the charred lot was sold to present owner Loyd Waites.

The other side of Lexington Avenue, "the Arcade" side, was built much earlier, in 1867, as a private home of landowner Charles Hoyle. It was sold, and the new owner extended the home to meet Lexington Avenue and turned it into "the Arcade" storefronts.

Kennard Jewelry Store, originally located inside the Oceanside Hotel and then moved to the Arcade on Lexington Avenue, was robbed of $400,000 worth of jewels. The culprits were never detained.

In the 1930s, the shops on Lexington Avenue consisted of Ludwig's Furs, DePinna fine clothing, Grande Maison De Blanc, Ada MacCarroll antiques, Schmidt and Son china, Mary Ruby gowns, Darrah and Darrah silver, Martha West sportswear, Carbone Inc. Art Goods, Yamanoka and Co. purveyor of oriental objects, Ward florists, Del Monte's restaurant, Mr. Latassa's tailor shop and Filene's clothing, to name a few.

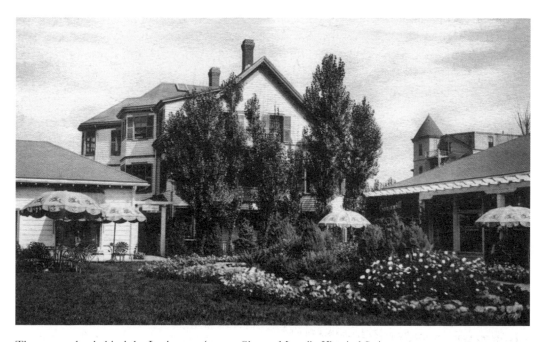

The tea garden behind the Lexington Avenue Shops. *Magnolia Historical Society.*

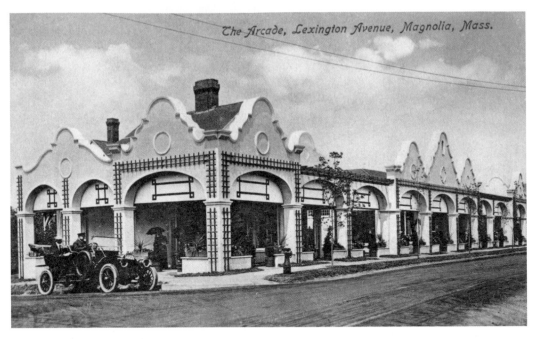

The Arcade side of Lexington Avenue was known as "Robber's Row." This side of Lexington Avenue retailed jewelry, furs, linens and other fine goods. *Magnolia Historical Society.*

With the invention of the automobile, the grand era began to dwindle. It was much easier to travel to new places. Magnolia's tourist income began to dwindle. The finer shops relocated to larger cities and "help" was no longer affordable; thus, necessity shops came to inhabit Lexington Avenue. In the 1950s, the Magnolia Towne Shop encompassed the entire Arcade side of Robber's Row. The row of shops was joined to promote an indoor mall offering ladies' clothing, children's clothing, penny candy, undergarments and more. The Magnolia Towne Shop eventually went out of business.

In the 1970s, Lexington Avenue boasted shops more suitable to those times. A more casual atmosphere of shopping and dining came about. The dress code for Lexington Avenue shopping had certainly moderated with the times. Now shoppers either walked to Lexington Avenue or drove themselves to it.

Number 2 Lexington Avenue was purchased by David Gardner and the Kettle Cove Pharmacy moved in. The mayor's son, Bob Alper, managed the Kettle Cove Pharmacy. The shop included a pharmacy, candy shop, gift shop and diner all in one. A few years later, Alper moved the business to the opposite side of Lexington Avenue, to the shop that once housed Ovington Brothers decorative items. It was there, in the basement, where Bob died accidently.

On a lighter note, a delightful couple, Len and Sandy Wickens, opened the Joy of Photography and the Joy of Giving at 2 Lexington Avenue after the pharmacy moved. They also had penny candy, but their main industry was portrait and landscape photography. Many of the photographs you see in this book were donated to the Magnolia Historical Society by Len Wickens.

The '80s era hosted shops on Lexington Avenue like Just for Fun Antiques, the Magnificent Gull, Dorothy's Casual Shop, Shamrock Ceramics, Yankee Floor Covering, the Dressing Room, A Spot of Tea, the Baby Exchange, the Oyster Shell Used Clothing, Ina Coiffure and Barbara's Beauty Shop, the Patio Restaurant, the First National Bank of Ipswich, Magnolia Magazine Shop and the Magnolia Bike Shop.

Colin McGilvary, who owned the Magnolia Bike Shop, recalls that the shop was "founded by accident." He and his buddies were looking for a place to "hang out." They rented a space across from the Surf restaurant and he put a sign in the window in 1972 advertising a bike shop. About six months later, the business had done so well that he moved his shop to Lexington Avenue. According to Colin, "It was then the bike boom started." As business flourished, he eventually procured three storefronts. With the help of one of his six children, Ed Berkman, the business prospered. Colin regularly rode his high wheeler (a gigantic wheel in front and a small wheel in back) on Lexington Avenue and in the Gloucester Horribles Parade.

Unfortunately, by the year 1990, the bike boom had diminished and the Magnolia Bike Shop was closed. Colin now spends his winter days in Silver Springs, Florida, and resides in New Hampshire in the summer.

Dorothy Cole "followed her high school dreams of working in the fashion industry" as a suit buyer for Filene's on Lexington Avenue. Dorothy attended Chamberlain School of Retailing in Boston and reached her goal of owning a store in 1990, when she purchased the Casual Shop and renamed it after herself. Although it had its heyday when Shore Cliff residents could shop there, Dorothy still maintains the store some twenty years later. When you see Dorothy, stop and tell her how proud you are of her ambition in life and her part in Magnolia's history.

The 1980s brought the demise of A Spot of Tea, and brought in the Magnolia Pub. The store on the corner of Lexington Avenue and Flume Road had been converted from outdoor wear to apartments, and the Joy of Photography had closed to welcome Birds of a Feather.

The year 1991 brought the seven-alarm fire that destroyed most of the shops along the Colonnade side of Lexington Avenue. (See more under Fire Curse in Homes, Hotels and Buildings.) With time, the Arcade side of Lexington Avenue suffered, as there was minimal business being done on Lexington Avenue after the great fire. The lack of activity put many out of business.

Today, the corner building that housed the North Shore Grille, Hakim's Egyptian treasures, Kettle Cove Pharmacy, the Joy of Photography, Birds of a Feather, and the Chocolate Café, is still standing. The franchise era has officially moved in and we have a Dunkin' Donuts.

Some businesses have stood the test of time on Lexington. The post office remains. The Patio Restaurant expanded into the building that once housed the First National Bank of Ipswich, with space left for an ATM.

The space where the Breakfast Nook made its famous coffee rolls has been abandoned and the old Magnolia House of Pizza building has also remained empty since the fire.

The space that once occupied the New Magnolia Hotel and Annie Ryan's Colonnade and rose "tea" gardens are a thing of the past. The metal-fabricated building that houses

The 2 Lexington Avenue location that was at one time a gentlemen's club, an Egyptian treasures store, a pharmacy, a photography store and a chocolatier is now Dunkin' Donuts, 2007.

J.D. and Myers Best Friends Inc. now stands in the ghost of the hotel's pretensions. Condominiums at 2 Ocean Avenue stomp on the fertile soil where ladies once shared tea.

Along the Arcade side of Lexington Avenue, where Kennards Jewelers, the Magnolia Bike Shop and Magnolia Towne Store once resided, is a personal art studio. Dorothy's Casual Shop remains next to that and Jennifer's Perfect Setting and a Montessori school encompass the rest of the Arcade. Moving up the avenue toward the library, the block that once belonged to the Slattery Company and housed Ovington Brothers, Kettle Cove Pharmacy and Magnolia Moss now has a Montessori school in its possession. Farther up the avenue, Peter Smith Booksellers is located in the first building on Lexington Avenue, constructed for retail, and the Magnolia Library Center remains productive.

Natural Wonders

Norman's Woe

The coastline that extends from Ocean Highlands to Hammond Castle is known as Norman's Woe. The name was established in 1682 when Richard Norman sailed out of Manchester and never returned.

Norman's Woe has seen the demise of many ships since that time. In 1814, a British cruiser drove itself to destruction on Norman's Woe. Later, in 1886, a group of Boston businessmen were "saved from their watery grave after their craft had been pounded to pieces in the small hours of the morning."

Perhaps the most famous wreck occurred in the seventeenth century, when the ship *Hesperus* was destroyed. A well-known Longfellow poem, "Wreck of the *Hesperus*," has defined a tragedy that occurred at this now famous reef. Written in 1842, the poem tells about a skipper who, during the winter months, took his only daughter aboard a schooner with him. A nor'easter arose, but the skipper refused to return to port. In order to save his daughter from the tempest, he tied her to the mast of the boat, but the vessel shattered on Norman's Woe. The girl's body was found on the rocks of Magnolia's back shore, still tied to the mast. (See Storm of 1839 in Storms and Quakes.)

Rafe's Chasm

Originally identified as Rafe's Crack, this large rock fissure was finally noted as Rafe's Chasm on maps in the 1850s. It is said the name comes from a freed slave named Ralph who settled near the chasm and built many of the rock walls that remain on Hesperus Avenue.

Located just off Hesperus Avenue, tourists are led by path through a beautiful botanical haven to the 10-foot-wide, 200-foot-long, 60-foot-deep chasm. The mammoth ledge that now forms Rafe's Chasm was, at one point, several miles deeper within the earth. It is believed that the chasm itself was formed from magma from lava flows from the center of the earth, along with millions of years of erosion and elevation. The pressure from the elements in the earth pushed up the rocks we see today. A form of ever-changing rugged beauty, water surges into the crack, splashes into the air and then retreats back into the great Atlantic.

Norman's Woe was the location of the wreck of the *Hesperus* and many other shipwrecks. *Magnolia Historical Society*.

The type of rock at Rafe's Chasm is called Cape Ann granite. This brownish pink–colored granite, according to Martin E. Ross, PhD, a geology teacher at Northeastern University, was formed over 450 million years ago. This type of granite was made famous in the nineteenth-century when it was used for several famous structures, including Boston's Longfellow Bridge and the Boston post office.

Visiting the chasm became a popular tourist attraction after the Civil War. Martha Marion died at Rafe's Chasm on July 10, 1877. She was visiting from Walton, New Jersey, and staying at the Willow Cottage. She and some friends had decided to visit the well-known place of interest. Ms. Marion was swept off the rocks and fell to her death. A metal cross was erected in her memory, but it was eventually either stolen or washed away by the almighty ocean.

In 1927 a right of way was deeded on land bordering Rafe's Chasm. The path leads from Hesperus Avenue to the sea and is still under legal issues at the time of this writing.

Rafe's Chasm Park was sold by the Trustees of Reservations in 1959 to the City of Gloucester for one dollar. The chasm itself is now actually located on private land, about fifty yards outside of Rafe's Chasm Park. The chasm has been skillfully fenced off by the landowner to discourage visitors, but the rage of the invincible ocean has demolished the fence over and over again.

The Flume

Formally known as Trap Rock Chasm, the Flume is located along the Magnolia rocks directly in front of the home at 11 Old Salem Path. Located on public property between

Rafe's Chasm, with the cross that was erected for Martha Marion, who died there on July 10, 1877. *Magnolia Historical Society*.

Cobblestone Beach and Rafe's Chasm, the 150-foot-long, 6-foot-wide and about 50-foot-deep flume was formed by waves that crushed out a thin fault line.

Great Stone Face/Witches' Rock

The profile rock is located on Shore Road, just beyond the stone archway, also known as "the Who Door." Magnolia's own rendition of the "Old Man of the Mountains" is the old woman of the sea. She can easily be seen on a drive down Shore Road.

The Sphinx

Another profile rock, the Sphinx, was located near Rafe's Chasm but can no longer be viewed, as it has been eroded by waves.

The Rock

The rock on the back cover of this book is located in a private yard on Lexington Avenue in Magnolia. It was said to be used as a U.S. geological survey marker, with its sister

The "Great Stone Face" located on Shore Road. *Sandra Vasapoli*.

Sphinx at Rafe's Chasm. *Magnolia Historical Society*.

The entrance to Ravenswood Park, a six-hundred-acre property owned by the Trustees of Reservations.

rock in Portugal, to measure the movement of continents and determine latitude and longitude sites.

Ravenswood Park

Businessman and philanthropist Samuel Sawyer devoted his efforts to preserve the woodland in Freshwater Cove. Over many years, Sawyer purchased countless wood lots and pastures in town. When Sawyer died in 1889, he allocated the land to a group of trustees to be turned into a park. With that, he also left a monetary gift of $60,000 so the park could be "laid out handsomely with driveways and pleasant rural walks." His wishes stated it would be named Ravenswood after the castle in Sir Walter Scott's *The Bride of Lammermoor*. It took the trustees of Ravenswood twenty-five years to lay the land to Sawyer's vision. Within those years, they continued to purchase and to be granted land.

In 1993, the trustees of Ravenswood transferred the six-hundred-acre property to the Trustees of Reservations. The well-maintained Ravenswood Park, with its entrance on Western Avenue, now has over ten miles of mapped walking trails. Along the journey many artifacts from the past are still visible, including cellars from old houses; visions of Old Salem Path; the cellar of the "pest house," which was used to isolate those who contracted smallpox; and of course the plaque at the site where the "Hermit of Ravenswood" once resided. (See the Hermit of Ravenswood in Early Landowners and Settlers.)

Man-made Wonders

Magnolia Woods

The area that we know as Magnolia Woods was originally owned by the Corliss brothers. The land itself is located in the southern section of the Great Magnolia Swamp, which extended from Bond Hill into Ravenswood Park across Western Avenue to end at the "little round pond." The Corliss brothers decided to develop the land as the Magnolia Golf Course. Unfortunately, the brothers went bankrupt. A second attempt was made in the 1930s that also failed. The city accepted the land in 1938 for money owed in taxes.

When Gloucester seized the land owned by the Corliss brothers, the city dump site, previously located at where Gloucester High School stands today, was then moved to the Magnolia Golf Course location. From 1939 until 1964, Magnolia had a "burning dump" that used fewer than two acres of land. In 1964, it became "just a landfill" that required an additional twenty acres of land. The decision to create a landfill turned the Great Magnolia Swamp and Round Pond into a sixty-foot mountain of trash.

In 1966, the Commonwealth's Division of Sanitary Engineering stated that "the present operation of the city dump constitutes a nuisance, a menace to public health, and a probable violation of the Massachusetts general Laws," yet the giant garbage mountain remained, along with the smell.

By 1974, neighbors organized and met weekly to fight the city over inadequate management of the landfill. In 1979, a state of emergency was declared because of the hazardous fires and inadequate drainage conditions of refuse water. Almost ten years later, in 1988, the dump was finally closed. The city wanted to cap the landfill with controversial "Naturite." Members of the Magnolia community banded together as a human wall and blocked trucks from entering the dump to pour raw sewage atop the mountain.

After ten more years, the land was deemed "safe." Mayor Bruce Toby was instrumental in extending the "Emerald Necklace," a string of green parks, and Magnolia Woods was dedicated parkland. Magnolia Woods now extends Ravenswood Park across Western Avenue to seven soccer fields, one softball field and walking paths that eventually lead to the end of Englewood Road.

Fran Hines, James Cook, John Crowningshield and Jane Porter break ground for the Magnolia Woods project. This land was used as a golf club, a city dump and now soccer fields. *Magnolia Historical Society.*

West Pond

In 1884, the area we know as West Pond was merely woods and swamp. In the year 1885, landowner John J. Stanwood built a dam to capture the water for a lake. By 1886, the map of land belonging to John J. Stanwood showed the area as Seaview Lake.

William Homans purchased the plot from Stanwood and renamed the lake Homans Pond. He then built the first icehouse at the site of what are now 14A and 14B Lake Road near Loring Cook's house. The icehouse was destroyed by fire in the 1900s, but the stone wall remains at the private home.

The land including the pond was then sold to Cape Pond Ice, "the coolest guys around." A large barn was built to keep the horses that brought the ice to Gloucester. In the back of the barn was a wagon shed, a blacksmith's shop, a cook's house and living space for the ice workers. Henry West worked for Cape Pond Ice for many years.

Henry's son Albert and daughter-in-law Mary West purchased the pond, the surrounding area and the ice company in 1936. They changed the name of the pond to West Pond, as it is today. The Wests then built a new icehouse on the northern side of the property.

The agreement for the property and ice company, signed on November 3, 1936, stated:

> *Now the said Mary B. West for herself and her heirs, executors, administrators and assigns of said real estate, and as part of the consideration of said conveyance, does hereby agree with said corporation and its successors and assign that she will not at any time in the future either directly or indirectly sell, deliver or dispose of any ice to customers other than those on the route, the easterly end of which is deemed to be Hesperus Avenue, nor will she permit any part of said land to be used for such purpose, and that in any and every sale or conveyance of any part of said land this day conveyed to her as aforesaid, she will insert and impose the restriction that the owners and occupants will not use the land so conveyed by her, directly or indirectly for carrying on the business of selling or delivering ice in any part of said Gloucester without first obtaining written consent of said corporation.*

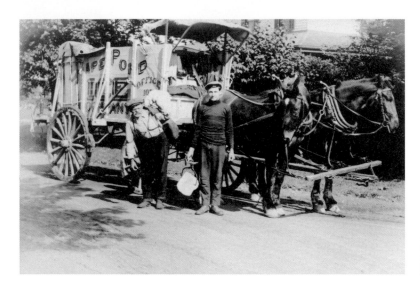

Henry West and a
young assistant deliver
ice. *Fran Hines*.

Although they were unable to sell or deliver ice to Gloucester, the Wests were able to
prosper in the business until the invention of the refrigerator came into play. The last
icehouse was torn down in 1945. Lumber was reused in two Magnolia homes, number
168 Hesperus Avenue and the cottage next to it.

West Pond is still used for many recreational activities such as fishing and ice skating.
The art of figure skating was introduced to the Magnolia residents by Michigan natives
Mrs. Mary Abbott Knowlton and her brother Frank Abbott, who had the experience
of cold winters and knew how to ice skate. Remember, back then there were no "shoe
skates." The high-tech skate was strapped onto the bottom of a boot, with the hopes it
would stay there. Mr. West always measured the ice to make sure it was thick enough
and he would forbid anyone to skate before his approval. Tony Muller also seized the
job of ice patrol for many years.

Someone did drown in the West Pond. Mr. West's great-grandson Lenny Carlson
drowned in 1941. Lenny fell out of a canoe, was unable to swim to the shore and
drowned. The men tried using grappling irons, but the mud at the bottom of the pond
was so thick that men had to use dynamite to vibrate the waters and raise the body.
Lenny Carlson's remains are buried in the Magnolia Cemetery.

Old Salem Path

As the Conant followers were making their way to Salem, they followed a pre-existing
Native American path that led them from Stage Fort, down Hesperus Avenue, along the
beaches of Magnolia, Manchester and Beverly and onward to Salem—the Old Salem
Path. The Native American path also followed a course through the Cape Ann woods
toward Magnolia. Today, sections of Route 127 are the oldest trail (highway) resulting
from the Massachusetts Bay Colony.

The last icehouse on West Pond was torn down in 1945. Some of the lumber was used to build two homes in Magnolia. *Fran Hines.*

After 1685, one could travel on a public road from the Meeting House in Gloucester (located near today's Grant Circle), southerly through town, westerly across the Cut and through Freshwater Cove and Kettle Cove to the Manchester line, continue through Manchester and Beverly to the Ferry landing.

In 1787, the people wanted to change the way of the road because the hills at Kettle Cove Hill and Freshwater Cove Hill were too steep for wagons. On December 18, 1787, it was decided that the road would be altered south of the hill at Freshwater Cove and north of the hill at Kettle Cove. The road would then travel through the land of Sawyer, Ellery, Proctor, Gilbert, Trask and Herd.

The old road to Salem was divided then into two sections, the Cove Hill section in southern Magnolia and the Freshwater Cove section near Ravenswood Park and areas to the north. The Cove Hill Road section remained until the nineteenth century as the "Old Path to Salem." It was about three quarters of a mile long from the entrance of Magnolia Woods down Western Avenue to where it met Magnolia Avenue. The new Cove Road was curtailed around the back side of the May House at this time to make for easier travel.

The Freshwater Cove section was labeled the "Old Pest House Road" by John Mason, who drew the map in the 1830s. During the smallpox outbreak of 1773, a "pest house" for the sick was built on this road. (The foundation of the "pest house" is still visible in Ravenswood Park.) The "Old Pest House"/Freshwater Cove section is about one and a half miles long. It begins on Western Avenue near Stage Fort Park, winds over and around the hills in Ravenswood Park and returns to Western Avenue at Magnolia Woods.

Vestiges of Old Salem Path are still in existence. A large portion from Stage Fort Park to Manchester remains and it can also be found in Magnolia Woods, Ravenswood Park, by the Great Magnolia Swamp. In Manchester, Old Salem Path is now Ancient County Way, and in Beverly it is at the Commons.

"Old Salem Path," "New Road to Salem," "Cove Road," "Road to Manchester," "Boston Road," "Pest House Road"—whatever you want to call it—was legally deemed Western Avenue in 1892, when it became state highway Route 127. This road has been available for public use for over two hundred years of recorded history.

Little Heater

In 1724, a gravel road was laid out from Little River to Kettle Cove. If one was coming from Gloucester, the road was called "the road to Kettle Cove"; if one was coming from Magnolia, the road was called "the road to West Parish." It soon received its nickname, "the little heater," as the wealthy locals would race horse and carriage along the curvy path.

The first map of this road shows that it veers to the right before the train tracks, continues across the lily pond and meets back at what is now known as Kondelin Road.

One of the racers, an owner of Eastern Railroad, often had trouble racing his horses as they were afraid of the steam train. He bought the necessary land and rerouted the road to the track it follows today.

Magnolia Avenue was officially entitled in 1774 to allow travel from West Gloucester to Salem via the stagecoach stop.

Burke's Playground

A rock on the outskirts of the grass states that the playground on Western Avenue was named after Mayor John J. Burke Sr. (son of "Cappy") in 1936. The field hosts a playground, a softball field, a batting cage and a large grassy field. Many adults played here as children, and their children will play here too.

John "Jack" Burnett was first to establish the Magnolia Lions Pee-Wee six-man football team.

Bill Knovak has been caring for these grounds and coaching or playing softball on them for as long as I can remember. A conversation with "Mr. Bill" reveals that the first year he coached Magnolia Lions girls' softball was the year that Diane Colby played for the B team in the early 1980s. In the many years he coached, he led the team to numerous championships, with year-end banquets held at the Surf. Bill was chief in the foundation of the Magnolia Men's League softball in the mid-1980s with three teams: Bill Fraga's team, sponsored by FMP (Fiahlo Metal Products); Ron Muise's Team; and Knovak's team, sponsored by the Edgewater Café. The Men's League was extremely successful under the direction of Knovak and soon included teams like the Magnolia Pub; the Northeast Kids, sponsored by Ed Downs of Northeast Ford Engines; Magnolia Variety; and many others. Bill also secured the large scoreboard with a donation from Coca-Cola via the Edgewater Café. Knovak, a friend, a coach and an educator, should be applauded for maintaining Burke's field and keeping Magnolia's sports teams running.

Work and Play

Magnolia's Workforce

In 1800, the average family had to support 7 children. By 1900, the average number of children dropped to 3.5, and in 2004, the average number of dependants was only 2.

In colonial times, small farms, fishing by net trap or long line and lobstering were the main vocations required by the fourteen original families to survive. The beauty of Magnolia Harbor overlooking the Boston skyline has provided the residents the luxuries of oceanside living and a means to provide food for the table and money in the wallet. Seine boats would leave the beach with a net and a crew. The crew would row around until the net was filled with fish. They would then drag the net back to the beach where they would sort the fish, put them on ice and transport them to the local markets for sale.

The 1870s brought the first tourists to the area and workers were needed for the service industry. The workday then was unlike that of today. Men drove ice from what is known as West Pond, delivered it via horse and buggy and pronged it up into your ice box as modern refrigeration. Usually placed on the front porch, an icebox would be used to keep grocery items fresh. Residents and hotel owners would leave a card in the window to let the iceman know how many pounds to leave. No card, no ice.

The tourist industry created additional jobs, including carpenters, maids, livery, teamsters, horse stables and shoeing, blacksmithing, trash removal and other odd jobs.

At the turn of the twentieth century, the average salary was $0.22 per hour, with an average annual salary of $200.00 to $400.00. In 1902, the Gloucester auditor's report showed $1421.24 spent on horseshoeing and blacksmithing. In 2004, no money was spent on horseshoeing, but $21,650.00 was spent on tires, not including those for the fire department.

Magnolia experienced grandeur with the many fine hotels that were located within its boundaries. The Hesperus, the Oceanside, New Magnolia Hotel, Oak Grove House and The Aborn are but a few of the hotels that one day stood majestic over the landscape. If history could speak, it would tell of the many famous faces seen among these hotels and the many hard workers they supported. In the early 1900s the population of Magnolia was generally three hundred year round, expanding to three thousand in the summer. The tourist market grew to grandeur, melted slowly after World War I and was punched out by the stock market crash in 1929.

After World War II, the change in lifestyle and opening of more accessible roadways, coupled with the invention of the automobile, made it difficult for the Magnolia grand hotels to make a profit. Guests simply wanted to see more of the country. Therefore, seasonal guests decreased in numbers and the hotel business suffered.

After the fire in 1958 that destroyed the Oceanside Hotel, many shops were not able to support business and soon closed. This prompted many of the business owners and summer residents to discontinue their stays in Magnolia.

After World War II, the tourists came only seasonally and factories were being built up the highway. The majority of Magnolia's workforce then began to commute.

Today, most Magnolia residents work outside of the village. Transportation, college education and many other factors make this the norm. The average annual salary today is $52,084.00.

Now there is but one hotel in Magnolia, the White House (which is actually pink), owned by the Steel family. Lexington Avenue and Cole Square shopkeepers and restaurateurs are few, modest and ever changing.

Sawmills

There were three sawmills in Magnolia, the first I suspect was behind 749 Western Avenue, built "near Wolfe Trap Brook." The water ran down Western Avenue toward Clarks Pond. The second was said to be behind the building we know as Blynman School. In 1682, Jeffrey Parsonns Sr., Job Coit and Samuel Sargent were said to "have liberty of a stream between Freshwater Cove and Kettle Cove to set up a saw mill." The third was believed to be near the dam at West Pond.

Recreational Activities

Way back when, the main type of music that was listened to was ragtime, its roots established from minstrel shows and plantation songs. It reached its popularity between 1897 and World War I. Magnolia residents hosted many minstrel shows for entertainment both at hotels and private clubs. During the hotel era, band concerts were a welcome form of entertainment. John Philip Sousa and his Marine Corps band were regulars at the Oceanside Hotel. In later years, the hotel also offered movies.

Another favorite pastime was bowling. Lanes were available at the Men's Club in the basement area, at the Oceanside Hotel and another on Fuller Street. Although the Oceanside and Fuller Street lanes no longer exist, the alleys at the former Men's Club, now the Landing Apartments, can still be viewed in the basement area. For more entertainment, in 1886 a roller-skating rink was built at Stanwood Grove, now Lowe Drive. Horseback riding was also a popular pastime. The stables would hire men to take the ladies out for a trot.

Magnolia Beach and Harbor have enabled boaters and sunbathers to bask in the hot North Shore sun for many moons. The beach itself has had many names: Coy's Beach, Crescent Beach, Gray's Beach and Magnolia Beach. The name Coy belonged to the Coy family, who moved to Kettle Cove from Manchester in 1706. The name Crescent

Beach may have been due to the shape of the beach. It is unknown where the name Gray's Beach came from, but one would surmise, with White Beach and Black Beach nearby, possibly this is where the name arrived. Magnolia Beach has been its name since the name Magnolia was adopted.

Bathhouses and pavilions were erected on Magnolia Beach in 1890. At that time, people rented bathing suits. The suits for ladies consisted of heavy flannel, long-sleeved serge suits with bloomers, along with corsets, stockings and shoes. Bathing attire has changed significantly throughout the years.

The hotel-owned pavilion at the beach featured bleachers so people could enjoy the polo matches, band concerts, horse shows and gymkhana (muscle men and acrobatics).

A nine-hole golf course was located at the site of White Gables on Western Avenue just over the Manchester line. It has been said that President Wilson landed his plane at the Magnolia Golf Course—if this is so and can be proven, the history of Magnolia would certainly become more significant in the big picture.

The Manchester Bath and Tennis Club was built in 1912 and was originally known as the North Shore Swimming Pool. Hesperus Avenue sported the tennis courts located next to what are now the Philpott House and the Magnolia pool that was once part of the Oceanside landscape.

Polo players on Magnolia Beach. The hotel's bathing pavilion can be seen in the rear of the picture. *Magnolia Historical Society.*

The Magnolia Clubs

American Association of Retired Persons

This association was organized in 1973. It encompassed 180 members from surrounding areas and was part of a national organization of about ten million members at that time.

Magnolia Merchants Association

Much like the chamber of commerce, the Magnolia Merchants Association was formed by a group of local businesspeople concerned with the growth of business in the community. Their duty was to provide a pleasant service to the general public and promote the Magnolia workforce. The group disbanded with the institution of the larger Cape Ann Chamber.

Magnolia Community Association Inc./Neighborhood Association

In the 1960s, a group of Magnolia residents formed the Magnolia Community Association and met for the purpose of "maintaining and improving Magnolia, and to be able to express the opinions of residents on subjects of community interest."

In the 1980s, the Neighborhood Association was established to maintain basically the same purpose. Since then, the Neighborhood Association has been influential in preserving the beauty in Magnolia. They have stopped the building of six large, square, brick buildings on the former Oceanside property, ceased the traffic of eighteen-wheel trucks on Magnolia Avenue, discouraged the use of Naturite to cap the landfill and put an end to the discussions on a police firing range at the end of Englewood Road. The Neighborhood Association has financed the repair of West Pond Dam, the Magnolia Pier and Float and was instrumental in establishing the soccer fields on the corner of Magnolia and Western Avenues and Surf Park on Raymond Street. The Neighborhood Association continues its mission today.

Magnolia Girl Scouts

The Girl Scouts in Magnolia began with the direction of Ellen Fiahlo and Dorothy Talbot. In my day, the group of second- and third-grade Brownies met at the Magnolia Library Center weekly with leaders Ivy Baughn and Mary Latassa. At this time, Magnolia Brownies have pooled with West Gloucester Troops. (Any of you former Brownies will get the pun on pool.)

Magnolia Boy Scouts

Magnolia Boy Scouts came about in the 1930s under the direction of Frank Davis, John Carter, Albert West and Paul Hines Sr. The pack continued to work on merit badges until the 1980s, when it, too, united with Gloucester. Roy Sutherland was the only son to become an Eagle Scout.

Magnolia Harbor Association

The Magnolia Harbor Association was set up as a nonprofit organization to promote safe and pleasurable boating experiences in the Magnolia waters. Lane Peacock and Don Libby were the main contacts. This association is now defunct, and Mr. Peacock and Mr. Libby are both deceased.

Magnolia Lions Club

The Magnolia Lions Club began with twenty-three members and was first chartered on June 7, 1946. The acronym "Lions" stands for Liberty, Intelligence and Our Nation's Safety. The club's first secretary was Joe Ballas. The presidential role is voted on each year by the members, the original brass bell and gavel are allocated to the new president and the retiring president then becomes chairman of the Lions Club Auction. The acting president at the writing of this book is James Fiahlo.

In its heyday, the Magnolia Lions Club serviced the Magnolia Community and surrounding area with its nonstop drive of volunteerism. The Magnolia Lions supported numerous sports teams; hosted a yearly banquet at the Surf; collected used eyeglasses to donate to those in need; organized an Easter Sunday breakfast and a Halloween party; offered a scholarship; manned the chuck wagon for the Saint Joseph's Fair; and held the annual Lions Club Auction.

The first Magnolia Lions Club Auction was held in 1953 in Harvey Burke's front yard. At the time, it was mainly a bake sale, dinner and raffles to raise money for Lions Club charities. As requested by Harvey's wife, the auction was later moved to the Magnolia Landing area, where it became the biggest Magnolia event of the year. For many years,

the auction lasted until the last piece was gone. Many times this event that staged an auction, a betting wheel, a white elephant table, kids' games, raffles, pony rides, island tours, dinner and drinks lasted well into the morning hours. Magnolia residents call it "the day when everybody in Magnolia swapped junk." The Magnolia Lions Club raised over $25,000 in its banner year.

With time, some neighbors began to complain about the noise, and the auction was knocked back to a midnight curfew. Many factors contributed to the end of the Lions Club Auction. Due to noise complaints, the need to close Shore Road to the public for a day and the fact that the good stuff was being sold at yard sales, the auction disbanded. The Lions Club began to host a yearly yard sale on Lexington Avenue, but within a few years, it too was ended. Many a Magnolia man's funniest stories come from remembering the auction.

The Magnolia Lions Club continues its mission to donate money to great causes as scholarship and the Massachusetts Eye Research foundation through their annual Striper Tournament and Casino Nights.

Island Action

Those of you who know me well knew I had to write *another* piece about the 1987 island party. Although Magnolia folks have been using Kettle Island for merrymaking for many,

The Magnolia Lions Club auction was first held in the yard of Harvey Burke. It became a popular fundraiser for the Magnolia Community. *Magnolia Historical Society.*

many years, a grand party was held on the shore of the island on the day of the Magnolia Auction in August of 1987. This event was hosted by the generation that encompassed Doug Shatford, James Fiahlo, Peter and Ian Lake, Bill Fraga, Rich Rattray, Robert Bouchie, Wayne Rose and Billy Hull. It was also attended by the younger generation of Michael and John Ramos, the Gilliss boys, Agnes Spinola, Cathie Hull, Kristin (Baughn) Rattray and myself, as well as the older generation (I won't mention your names, but you know who you are) and, of course, the infamous Bachary boys.

Electricity (via a generator), printed party hats, a huge bonfire, numerous grills, lobsters, steamers and corn were available for this grand occasion. This well-planned party offered quarter-hour boat rides to and from the island. An "Island Action" cap, designed by Doug Shatford, can be viewed at the Magnolia Historical Society.

It was planned to make this an annual event, but with the ending of the Magnolia Auction and the scare of the great electrical storm in 1988 (everyone's hair was standing on end!), the island party remains just a memory.

Women's Community Club of Magnolia

The Women's Community Club of Magnolia was formed in 1947. The first president of the eighty-three-member club was Mrs. Leon (Barbara) Alderman. Agnes Ernst, daughter of Jonathan May and an original charter member, served the Women's Community Club of Magnolia for sixty years.

The now fifty-eight-member club motto states, "Be a good neighbor. Each one, reach one." The object of this club "shall be to promote civic, social, and educational interests in the community."

The Magnolia Women's Community Club belonged, at one time, to the National Federation of Women's Clubs. Husbands would help with projects such as minstrel shows, Flora Dora girl productions and fundraisers. The federation, in turn, would choose to which foundation all the money the ladies earned would be sent.

In the 1960s, the club broke off from the National Federation as the women could not keep up with the required traveling and wanted to choose their own beneficiaries. Today the Women's Community Club of Magnolia has numerous causes and scholarships they donate to on a regular basis, coupled with many generous neighborhood donations they make each year.

Magnolia Beach Corporation

Magnolia Beach Corporation is a private organization that is open to all permanent and seasonal residents who live within the defined boundaries of Magnolia.

The battle for the beach began in the 1930s, when the beach was proclaimed as private. Magnolia residents wanted to use the beach. Loring Cook Sr. and Winn Story testified that the beach had been public property. Defending lawyers argued, "Are we

Magnolia Women's Community Club members pose for a picture in December 2007. The club recently celebrated sixty years of community service. *Seated*: Theresa Rogers, Nancy Davis, Fran Hines, Mary Quill, Pat Geraghty, Carol Sutherland and Sandra Vasapoli. *First row, standing*: Noreen Gilliss, Regina Girard, Judy Melanson, Cathy Doe, Dolores Bonaccurso, Dolly Hull, Gail Mondello, Jan Freelove, Eleanor "Buzz" Mason, Sandy Dupray, Maryanne Frontiero and Noeline Kohr. *Back row*: Donna Kecyk, Jan Jonsson, Leslie Beaulieu, unknown, Patricia Fairhurst, Maureen Colby, Susan O'Leary, Ann Slocum, Kathy Rogers, Irena Burke, Donna Chamberline, Sally Peek and Linda Geary. *Sandra Vasapoli.*

going to turn this land over to the riff-raff or are we going to find the real landowners." The Magnolia Beach Corporation was established in 1951 by a group of residents who purchased a section of the beach for their own private use. The Coolidge family allowed them to carry on their sunbathing to the end of the beach. Later, the beach end was transferred to the Trustees of Reservations, who offer a twenty-five-year lease to the Magnolia Beach Corporation to care for the property and, in return, the members can use that section of the beach. The corporation is run by a member-chosen board of directors. The current president of the Magnolia Beach Corporation is Sally (Hines) Peek.

The annual membership fees are used to pay for the salary of the beach custodian and maintenance of the beach facilities and parking lot. In the 1950s, membership dues were ten dollars per family; almost sixty years later the yearly dues are seventy-five dollars.

Storms and Quakes

Cape Ann Quake of 1755

The quake hit on November 18, 1755, with its epicenter in Ipswich Bay. At the time, the tallest structure in the area was only one story, so the quake was not said to have done a lot of damage to buildings. However, chimneys, stone walls and bricks were strewn so thick across roads that no carriage could pass. Soil liquification produced geysers as far as Newbury.

By today's standards, the quake would have measured 6.0 to 6.3 on the Richter scale. Shocks from this quake were felt all the way to Halifax, Nova Scotia, and aftershocks were frequent along the northeastern coast in Massachusetts.

Blizzard of 1839

This winter storm struck on Sunday, December 17, 1839: "A southeast gale lashed the New England coast driving rain and snow in its path." More than twenty shipwrecks were noted in Gloucester due to the fierce storm. In the efforts to save ships, many masts were cut, but still many were slashed from their moorings and carried adrift to smash upon the island of Magnolia's Norman's Woe. The storm left bodies of both the living and dead to plague the shores.

Henry Wadsworth Longfellow used fact and fancy to write about the schooner *Hesperus*. In his poem "The Wreck of the Hesperus" (see more in the Norman's Woe section in Natural Wonders), the craft meets its demise at Norman's Woe. A woman was tied to a mast in an attempt to save her, but she was later found washed up on the shore.

Earthquake of 1925

The center of an earthquake hit Cape Ann, Massachusetts, on January 7, 1925, at 8:07 a.m. The rumble was felt from Providence, Rhode Island, all the way to Kennebunk, Maine.

Thunder Blizzard of 1969

February 22–28, 1969, marked the days of the thunder blizzard of 1969. Meteorologists were unable to predict the ferocity of this storm. Originally, the forecast called for two to four inches, but the thirty-one-inch snowfall left many without power and stranded hundreds of people and cars throughout Massachusetts. One of those couples stranded was my parents. Then pregnant with me, Sally and Sandy Peek were stranded in their car on Route 128. They trudged through the blizzard to the mall, where they spent the night with many other stranded travelers.

A headline in the February 26, 1969 edition of the *Gloucester Daily Times* read: "State of Emergency Called" by Mayor Joseph F. Grace. Even working around the clock, snowplows were unable to keep up with removal. City manager and Magnolia resident Paul Talbot was one of many who didn't sleep during the course of the storm.

Snowmobile owners and operators were urged to call civil defense if they wished to volunteer to transport patients to the Addison Gilbert Hospital. The Department of Public Works begged for volunteer help to maintain the city's plow vehicles. The DPW garage on Poplar Street was converted into an emergency headquarters. Front-end loaders were powered by the army, diverting the resident's attention away from their fear of the storm. School was cancelled for exactly one month.

Great Blizzard of 1978

Meteorologists were well known for incorrect predictions so many people ignored the threats of this blizzard. On February 6 and 7, 1978, the record of thirty-two inches in one day had been set, and up to fifty-five inches had been reported. The Great Blizzard of 1978 battered Cape Ann with mighty force for thirty-three hours.

On February 22–28, 1969, a blizzard hit Magnolia with gale force. *Fran Hines.*

The storm was formed when three air masses converged. Sixty-five-mile-per-hour winds produced an "eyelike" structure and trapped the storm over the New England coast. Physical damage to the land was awesome. Rockport's Motif No. 1 was swept from its foundation and toppled into the ocean. Newell Stadium at Gloucester High School was covered with five feet of water. The seawalls at Magnolia Beach were crumbled and washed away.

Storm-related deaths consisted of five men lost aboard the *Can-Do*, a forty-eight-foot pilot boat. Author Michael Tougias wrote *Ten Hours Until Dawn: The True Story of Heroism and Tragedy Aboard the* Can-Do. It has been said that a ninety-foot Coast Guard cutter, trying to save the *Can-Do*, was picked up in the ocean and washed over the breakwater back into the harbor. Several people perished in their cars along Route 128 as the snow piled above the exhausts of their idle vehicles.

The National Guard was called in for assistance. President Carter declared a "state of emergency" for this area. The State of Massachusetts called a driving ban and only plows and emergency vehicles were allowed to travel the roads. Route 128, Route 133 and Route 127 were all closed for days as the crews worked to remove the never-ending snow piles. There was no place to put the snow, so it was hauled away and dumped into the harbor.

Magnolia saw much ruin during the great blizzard. Along with a severe power outage, many downed trees and snowed-in houses, the wall at Magnolia Beach crumbled into pieces, the porch of the Manchester Bath and Tennis was completely knocked off and a Mustang was thrown from Hesperus Avenue near Cobblestone Beach over the rock wall and into a neighboring yard. Waves of water reached as high as Lexington Avenue. When the storm ended, the damage was immense.

No-Name/Perfect Storm of October 30, 1991

Without warning, the Perfect Storm hit Magnolia on October 30, 1991. Hurricane Grace melded with an Atlantic storm, leaving meteorologists baffled. The storm produced thirty-foot waves and wind speeds up to fifty knots. Magnolia Point was hit especially hard by this storm. The pier house, then owned by Edna Smith, at 58 Shore Road, and the adjacent garage that housed many old cars owned by Lawrence "Bunny" Jones, was taken over by the storm. The house collapsed and spilled its contents into the raging ocean. All but one of Bunny's vintage cars were swept away. If you dig deep enough in the sand at the bottom of the cement steps on Shore Road, you very well may find it.

Gloucester's shoreline was pounded with an estimated $24 million worth of damage.

The storm and noted shipwreck of the fishing vessel the *Andrea Gail* inspired Sebastian Junger to write the book *The Perfect Storm*. The book was later made into a movie starring Boston's own Mark Wahlberg. Many locals had their acting debut in the movie.

On October 30, 1991, the "Perfect Storm" pounded the pier house on Shore Road into the water.

The ocean-effect snow in 2005 began on January 22 and didn't stop for days. A record thirty-six inches of snow fell.

Blizzard of 2005

The ocean-effect snow of this blizzard with fifty-mile-per-hour winds began on January 22, 2005, and didn't stop for days. At the end of it all, Magnolia had settled into a record thirty-six inches of snow. A state of emergency was declared by Mayor John Bell, and Route 128 was closed due to whiteout conditions. The *Gloucester Daily Times* reported that "city officials called for help from the Massachusetts Emergency Management Agency…they received five Humvees and two front-end loaders." The National Guard was called in to assist with stranded vehicles on Route 128 and help with snow removal. About 130 homes in Gloucester were without power during the storm. The city sent over fifty snowplow drivers out to the streets, but due to the eight-foot snowdrifts, many plow vehicles failed. Due to the lack of available drivers, some of the minor streets in Magnolia and Gloucester were not even touched by a plow for days. Snow removal and cleanup continued for over a week. Public schools remained closed for the entire week, as there was no safe place for children to walk to school or wait for the bus.

Magnolia in Print, Movies, Television and More

The buildings, the people and the lovely willow trees of the fabulous era are gone, but a proud heritage is a great gift as we look to the future.
—Frances Hines, President, Magnolia Historical Society

Magazines

Magnolia Leaves

Founded and written by Mrs. Bray in the 1870s and '80s, this publication was Magnolia oriented. Marketed to Magnolia businesses and year-round residents, it told of the personal and business matters of the Magnolia neighborhood.

North Shore Breeze

The *North Shore Breeze* was a magazine written in the early to mid-1900s. It served as a weekly journal devoted to the "best interests of the North Shore." Many issues of the *North Shore Breeze* can be viewed at the Magnolia Historical Society.

Magnolia News

Lester Strangman produced this weekly newspaper in the 1930s and '40s.

Movies and Television

Mermaids

In 1990, Cher, Winona Ryder and Christina Ricci made their way to Magnolia to shoot the movie *Mermaids*. Set in 1963, and directed by Richard Benjamin, the movie portrayed a mother (Mrs. Flax, played by Cher) who had a dysfunctional relationship with her daughters Charlotte (Winona Ryder) and Kate (Christina Ricci). Within the tale, Mrs. Flax falls for a small-town storekeeper who eventually brings the family into line and shows them how to enjoy life together.

Lexington Avenue was made to look like it belonged in the 1960s. Magnolia Beach parking lot was strewn with old cars between shots. Magnolia Library Center was rented

Magnolia is transformed into "Masonville" to film a commercial for W.B. Mason.

by the producers for dining and a staging area. A few Magnolia residents made their acting debuts in *Mermaids*.

W.B. Mason Commercial

Lexington Avenue was turned into "Masonville" in the summer of 2001 when W.B. Mason filmed a commercial for their office products and delivery thereof. The commercial "Masonville 2000" can be viewed on the Internet on the W.B. Mason site in their Media Room.

The Borden Company

The Borden Company was interested in publicizing the fable of the curse of Kettle Island— no cow, horse nor sheep could survive on Magnolia Point for more than six months. Borden planned to send "Elsie" the cow to test the fable for advertising purposes. However, Borden Company decided that six months of research was too much and ditched the idea.

Did You Know?

*In 1953, Poet Robert Frost was given the key to the city of Gloucester.
*In 1956, Black Tuesday, there was no power in Magnolia.
*Blynman is still the busiest bridge in Massachusetts.
*Magnolia is the 1,586th most popular girl's name.
*Magnolia is latitude 42° 34' 25" north, longitude 70° 42' 40" west.
*Magnolia's elevation is fifty feet.

Bibliography

Abbott, Gordon, Jr. *Jeffrey's Creek, A Story of People, Places and Events in a Town That Came to be Known as Manchester-by-the-Sea.* Manchester-by-the-Sea: Manchester Historical Society, 2003.

"About Hammond Castle." Hammond Castle Homepages 1–2. www.ai.mit.edu/people/scaz/wedding/hammond.html (accessed January 30, 2003).

Alexander, Charles. *North Shore Directory Phonebook.* 1909.

Babson, John James. *The History of the Town of Gloucester Cape Ann.* Gloucester, MA: Peter Smith, 1860.

Beacon Newspaper

Dandola, John. *Living in the Past, Looking to the Future: The Biography of John Hays Hammond, Jr.* N.p.: Quincannon Publishing Group, 2004. See esp. p. 9, "Quincannon Takes on Hammond, Jr."

Dudley, David. *History of Essex County.* N.p., n.d.

Epstein, L. 2002. "Massachusetts Oldest Citizen Lives in Magnolia." http://www.ward5.com/Oldestresidentinstate.htm (accessed January 15, 2003).

"Facts to Keep by You." Gloucester, MA: Village Church, n.d.

Foster, Alice. *The Story of Kettle Cove.* Manchester, MA: The Cricket Press, 1939.

Garland, Joseph. *The North Shore: A Social History of Summers Among the Noteworthy, Fashionable, Rich, Eccentric, and Ordinary on Boston's Gold Coast.* Beverly, MA: Commonwealth Editions, 1998.

The Gloucester Civic and Garden Council Newsletter. Gloucester, MA: 2003.

Gloucester Daily Times

Hartt, Hildegarde. 1962. "Magnolia once Kettle Cove." The Charles Olson Research Collection. Archives and Special Collections at the Thomas J. Dodd Research Center, University of Connecticut Libraries.

"Hiking and Biking on Cape Ann." Cape-Ann.com. http://www.cape-ann.com/hiking.html.

Hill Benjamin D., and Winfield S. Nevins. *The North Shore.* Salem, MA: North Shore Pub. Co., 1890.

Horowitz, Shel. "Cape Ann: Massachusetts' OTHER Cape." FrugalFun.com. http://www.frugalfun.com/capeann.html.

Hunt, Vilma. "The Road to Salem In Gloucester." Unpublished essay, January 2003.

Kettle Cove and Fresh Water Cove Early Settlers 1642–1714. Gloucester, MA: Gloucester Town Records, Archive Committee, 1995.

"Magnolia Autumn House Tour." Magnolia, MA: Magnolia Historical Society, 1996.

Magnolia Leaves

Manchester Cricket

Naismith, Helen. *The Hermit of Ravenswood.* Salem, MA: Old Saltbox Pub. House, 1997.

Natural Resources Conservation Service. "Plants Database." U.S. Department of Agriculture. http://www.plants.usda.gov/.

North Shore Breeze

Pettibone, John W. "John Hays Hammond Jr. Biography (1888–1965)." Hammond Castle Museum. http://www.hammondcastle.org/

Pringle, James R. *History of Gloucester.* Gloucester, MA: Ten Pound Island Book Co., 1997.

Rasmusseun, C. 2002. "A Brief Post-Pilgrim History of Cape Ann." http://www.cape-ann.com/history.html (accessed January 15, 2003).

Ray, Mary, comp., and Susan V. Dunlap, ed. *Gloucester, Massachusetts Historical Time-Line, 1000–1999.* Gloucester, MA: Gloucester Archives Committee, 2002.

Spaulding, H.C. *Magnolia Souvenir.* Gloucester, MA: Frankwood Printer, 1886.

Tougias, Michael. *The Blizzard of '78.* Yarmouth Port, MA: On Cape Publications, 2003.

Wikipedia, s.v. "Curley, James Michael." http://en.wikipedia.org/wiki/James_Michael_Curley (accessed February 13, 2008).

Wright, John Hardy. *Images of America: Gloucester and Rockport.* Charleston, SC: Arcadia Publishing, 2000.

Interviews

James Cook
Paul Fiahlo
Judy Gilliss
Fran Hines
Bill Knovak
Sharon Lowe
Colin McGilvary
Sally Peek
Charlie Toye
Jeff Toye
Sandra Vasapoli